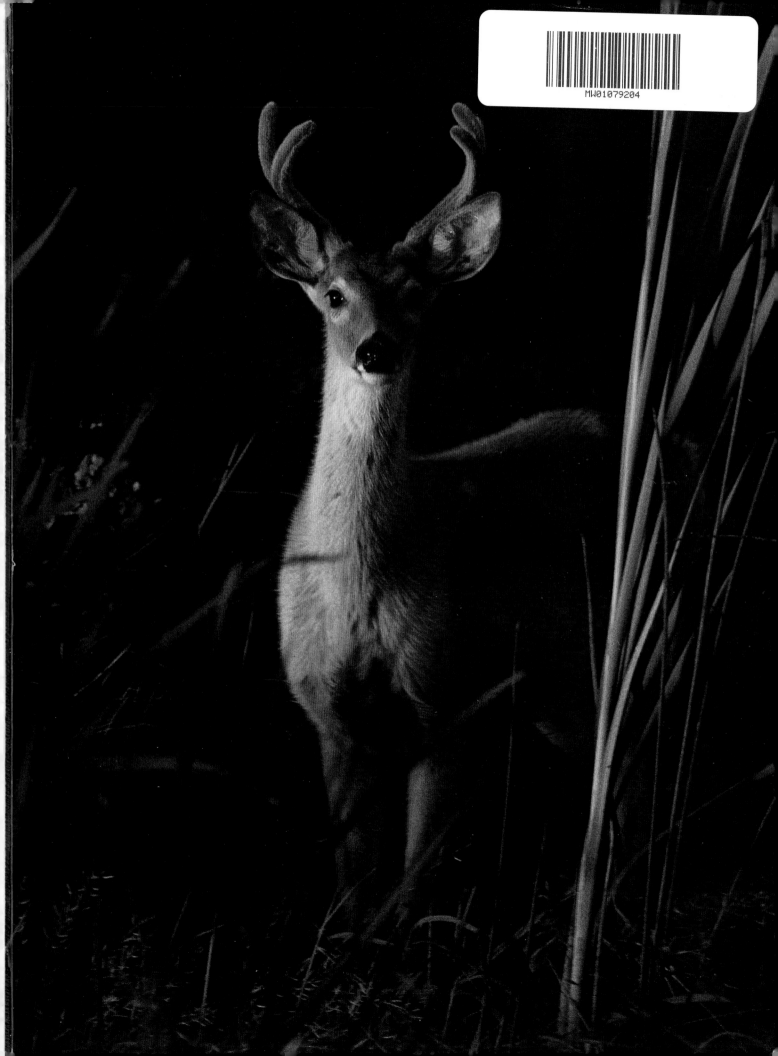

Montana Is ...

Montana in verse and photography by Mike Logan

Montana Is...

Published by Buglin' Bull Press, 32 S. Howie, Helena, MT 59601

ISBN 0-937959-82-0

Library of Congress Catalog Card Number 89-91009

Design by Laurie "gigette" Gould.

Publishing consultant and production by Falcon Press Publishing Co., Inc., Helena, Montana. Printed in Singapore.

Front cover photos:
Glacier autumn, grizzly bear, Manhattan Christian School, pasque-flower, bald eagle, eastern Montana sunrise, chokecherries.

Back cover photos:
Whitetail deer in velvet, moving cows near Deer Lodge, Helena Valley rainbow, capitol dome

Buglin' Bull Press
32 S. Howie, Helena, MT 59601

Dedication

To Judy
in honor of our 25th wedding anniversary,
November 24, 1985

Introduction

"Mike, I don't believe I ever met anybody who moved to heaven before, but I think you did."

Homer Loucks, my principal at Helena High, was chuckling. I had just recounted the excitement of snaking a hook-jawed seven-pound brown trout out of the Missouri River's frigid ice-rimmed waters the weekend before. It was mid-January of my first year in Montana, and that winter, 1968-1969, was one of the worst in Montana's history. I loved every minute of it.

"You're right." I agreed exuberantly.

Homer is still right.

I love everything about Montana. That first year, I fished over two hundred days. In the ensuing twenty years, I have spent at least that many days afield each year, fishing, photographing, and hunting this marvelous big-skied state. I still feel like I'm spending each day in heaven.

Not one picture in this book was taken with the idea in mind of doing a book. I took the pictures because I love the scenery, the wildlife, the people, and the state.

Montana Is . . . came about later. I just wanted to share some of the beauty I have been privileged to see.

This book, then, is what Montana is to me. I hope it will also be a lot of what Montana is to you.

As Homer Loucks said, all those years ago, I *did* move to heaven, and I realize that fact more fully every day I live in Montana.

Montana Is . . .

A fish hawk's nest
A whitetail fawn
And silver fog when comes the dawn.
It's brandin' calves
A harvest moon
And bugles in the afternoon.

It's bighorn rams
And mounded stacks
A weasel on the railroad tracks.
A paintbrush red
A big necked buck
And rifles in an old blue truck.

It's hangin' spurs
A wagon's rest
A sunset painted on the west.
A shake roofed barn
A hitch of blacks
The makin's in Bull Durham sacks.

It's great horned owls
A heron's catch
And blue grouse eggs about to hatch.
It's loggin' rigs
A gentle rain
A sunlit field of ripened grain.

It's shootin' stars
A snowswept ridge
A river crossed without a bridge.
It's well worn chaps
And mule deer's eyes
A champion steer that takes the prize.

It's crumblin' kilns
A red school house
And, struttin' proud, an old sage grouse.
It's bison herds
And dreams long gone
A portrait of a whistlin' swan.

It's wilderness
Abandoned mines
A winter sun that barely shines.
It's frost flocked trees
A sundown team
The answer to a hunter's dream.

It's cottonwoods
And goldeneye
And snow geese back to fill the sky.
It's heelin' dogs
And loadin' chutes
And Charlie Russell's high square buttes.

It's antelope
And huge snow plows
And cuttin' out the heavy cows.
An eagle's watch
Fawns sittin' tight
The lonesome sound of geese at night.

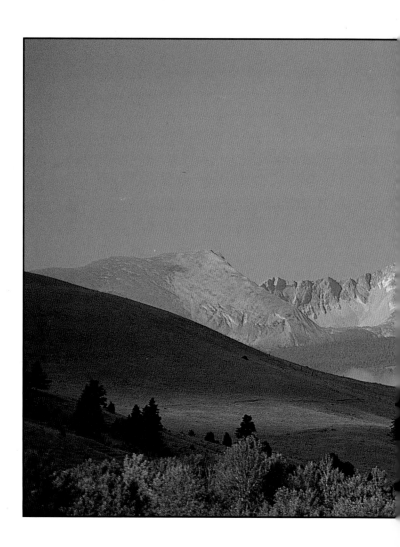

It's rainbow's end
And threshing bees
And quick red squirrels that lunch in trees.
It's shining lakes
And cold duck blinds
And bullet holes in frosted signs.

It's silhouettes
And tracks in snow
An evening on a high plateau.
It's closin' gates
A wooly flock
A mantled ground squirrel on a rock.

It's ridin' fence
A packer's string
And flowers so bright they seem to sing.
It's mountain goats
And hay new mowed
A pickup on a dusty road.

It's workin' hands
A river's course
And irrigatin' on a horse.
It's fishermen
And hook jawed trout
And prairie dogs just peekin' out.

It's tumbleweeds
A capitol dome
A momma osprey comin' home.
It's ptarmigan
A hay sled full
And snowfall on a blizzard bull.

It's marmot kings
And final turns
A fireset when the forest burns.
It's pickup men
A cactus flower
And, on a hill, an old firetower.

It's bitterroot
A country church
A chipmunk on a sagebrush perch.
It's winter elk
A cattle pen
And beargrass in a shaded glen.

It's grizzly bears
And snow capped peaks
And avocets with upturned beaks.
It's rodeos
And national parks
And wild free songs of meadowlarks.

It's aspen leaves
And early rides
And stackin' hay with beaverslides.
It's old homesteads
And aging mills
And monuments in greening hills.

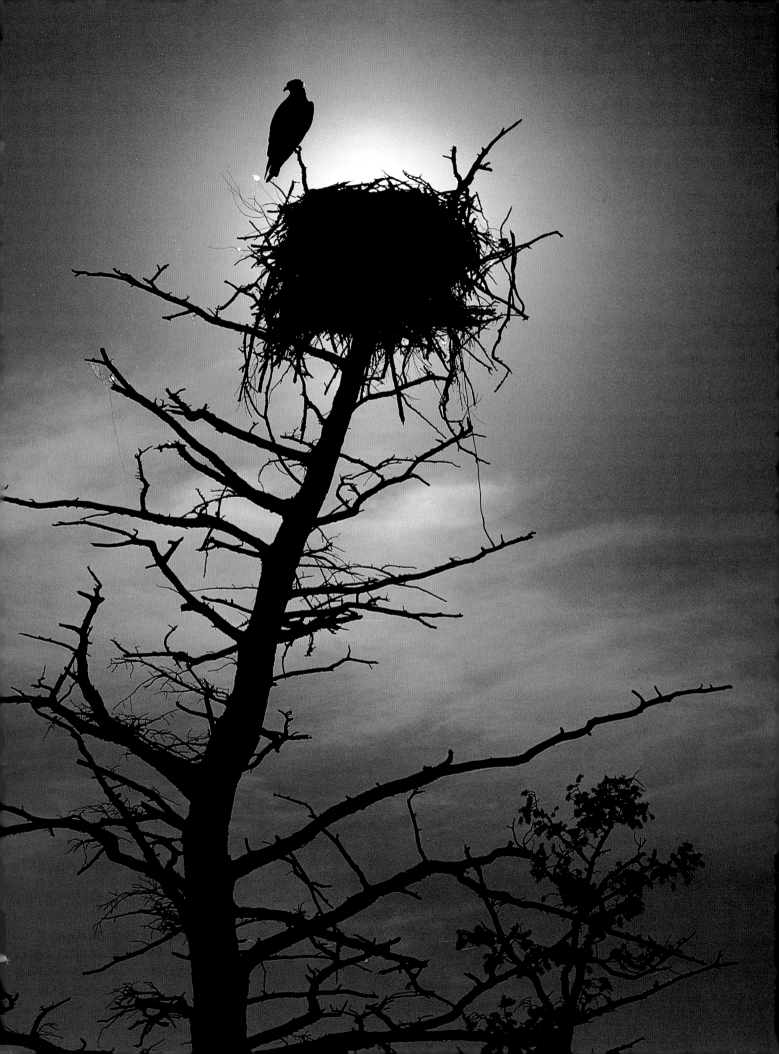

Montana Is . . .

A fish hawk's nest
A whitetail fawn
And silver fog when comes the dawn.
It's brandin' calves
A harvest moon
And bugles in the afternoon.

A *fish hawk's nest*

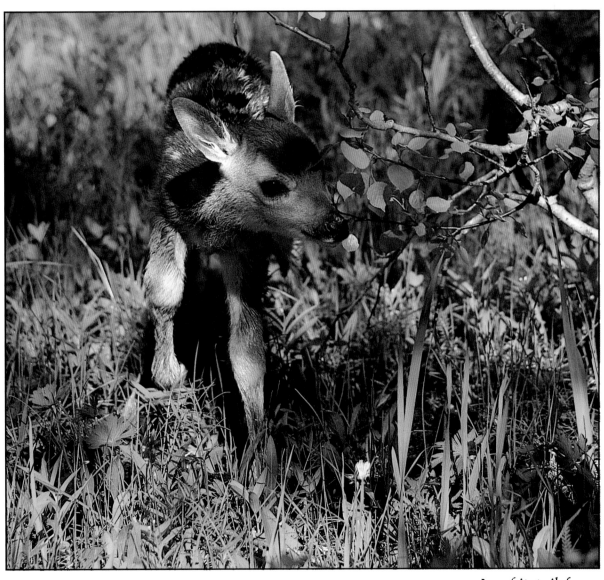

A *whitetail fawn*

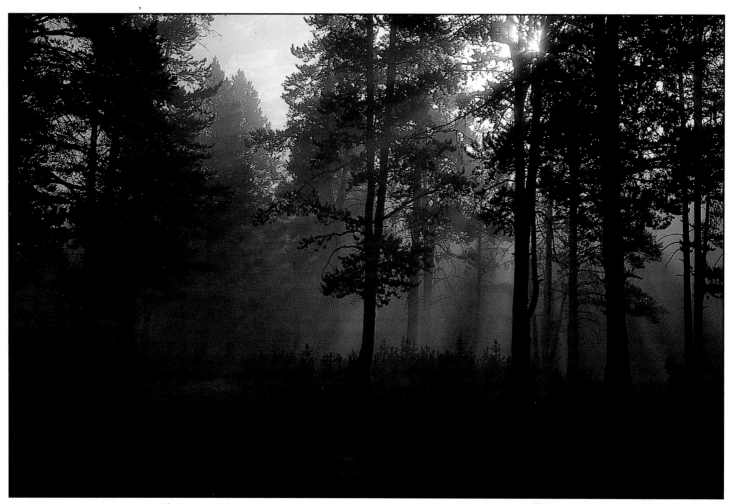

And silver fog when comes the dawn.

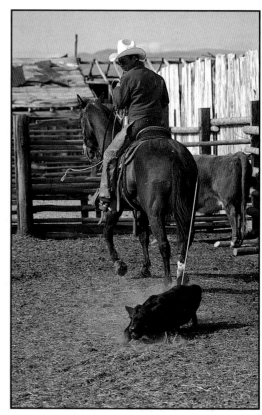

It's brandin' calves

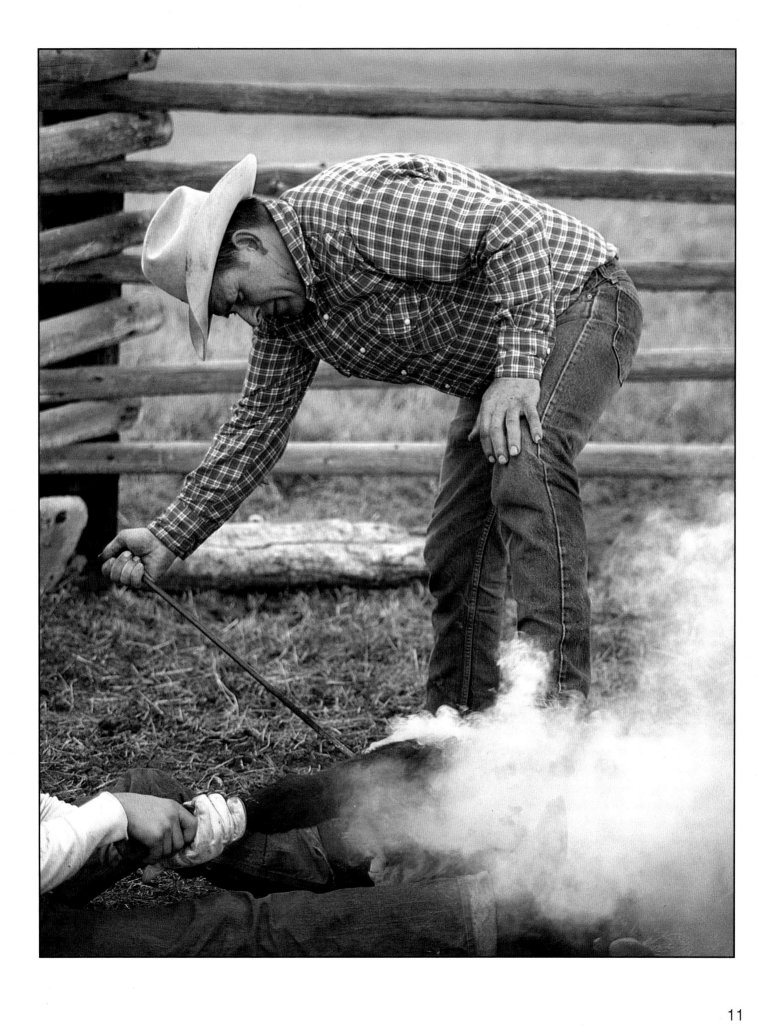

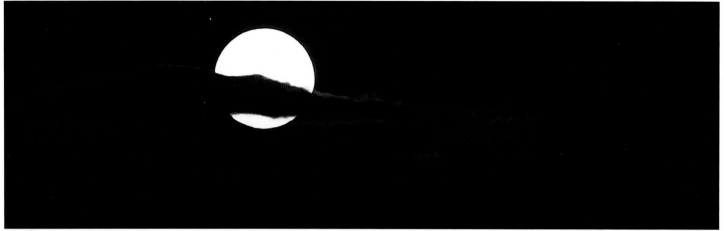

A harvest moon

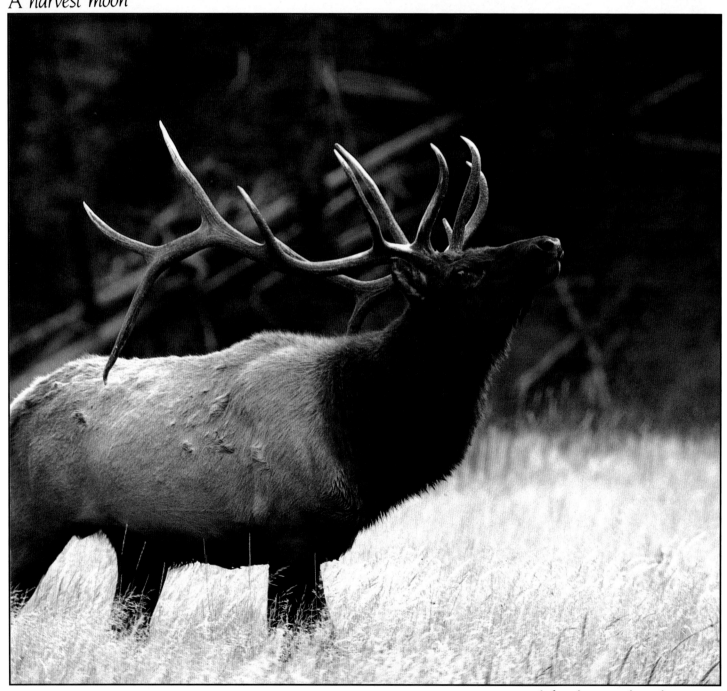

And bugles in the afternoon.

It's bighorn rams
And mounded stacks
A weasel on the railroad tracks.
A paintbrush red
A big necked buck
And rifles in an old blue truck.

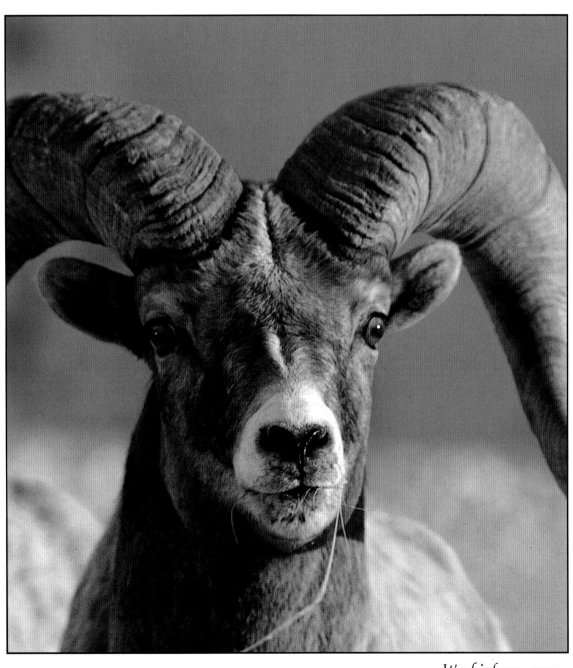

It's bighorn rams

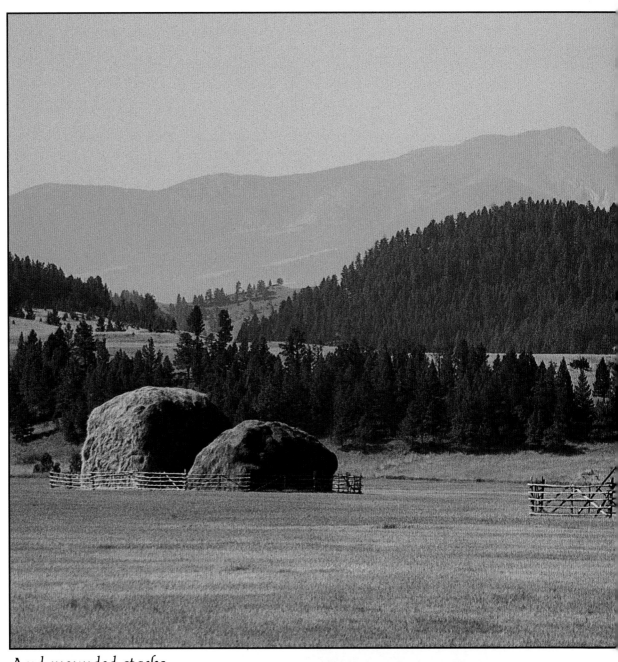

And mounded stacks

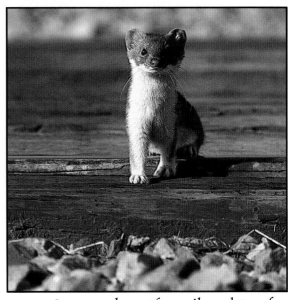

A *weasel on the railroad tracks.*

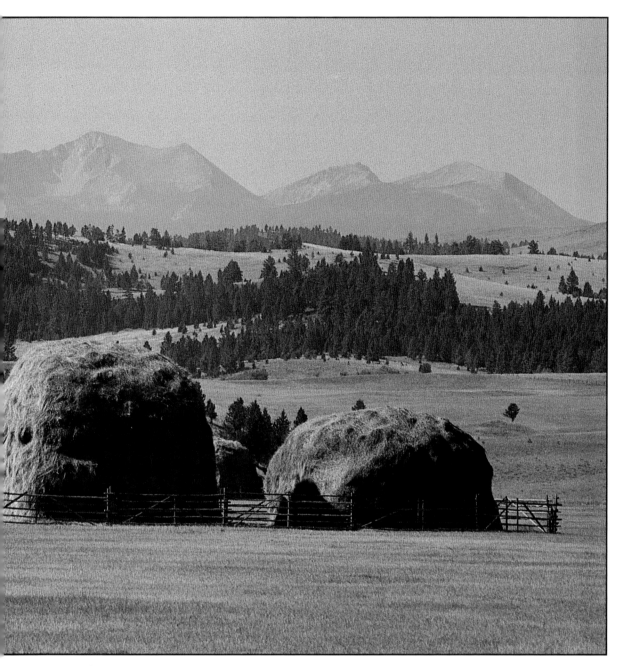

A paintbrush red

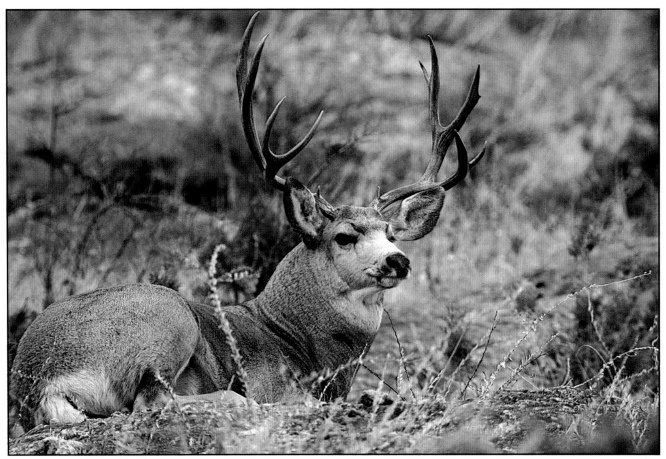

A big necked buck

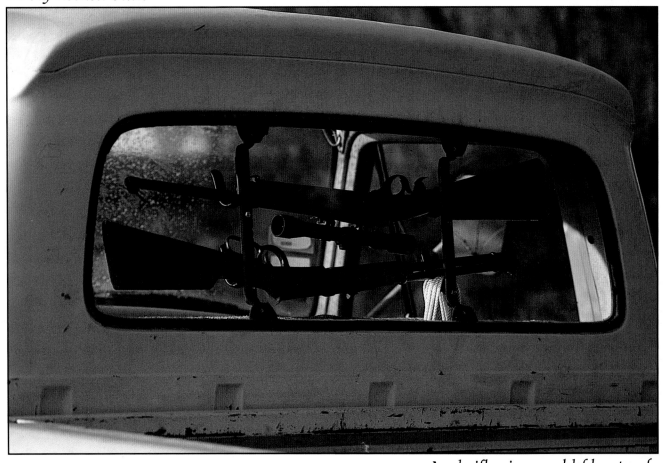

And rifles in an old blue truck.

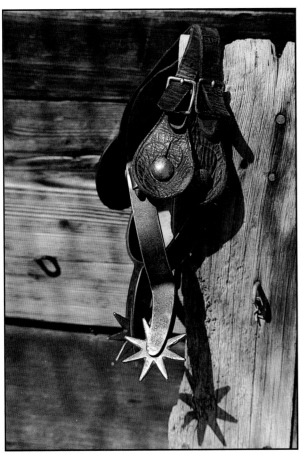

It's hangin' spurs
A wagon's rest
A sunset painted on the west.
A shake roofed barn
A hitch of blacks
The makin's in Bull Durham sacks.

It's hangin' spurs

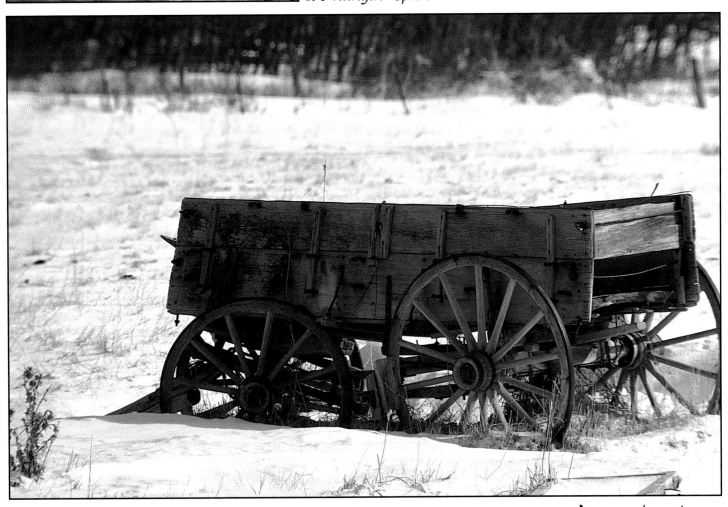

A wagon's rest

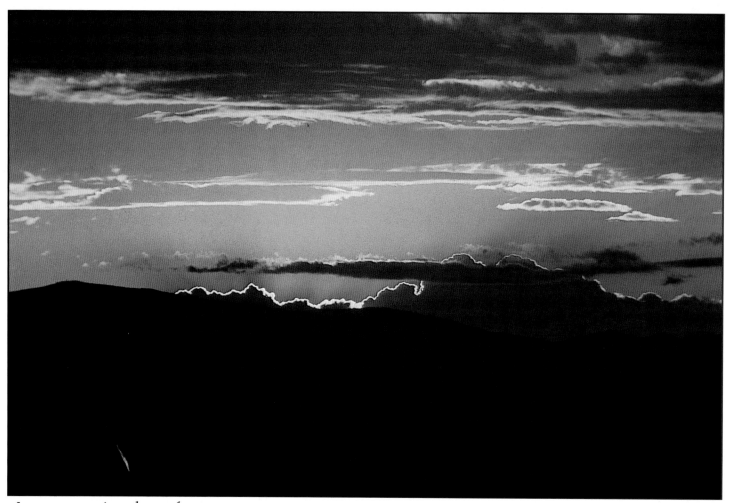

A *sunset painted on the west.*

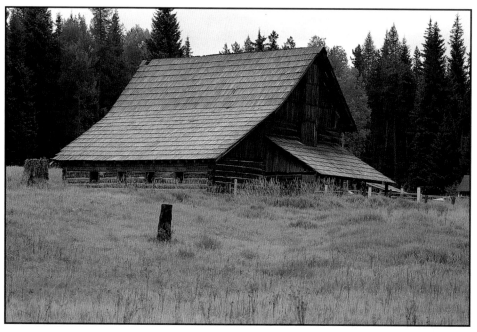

A *shake roofed barn*

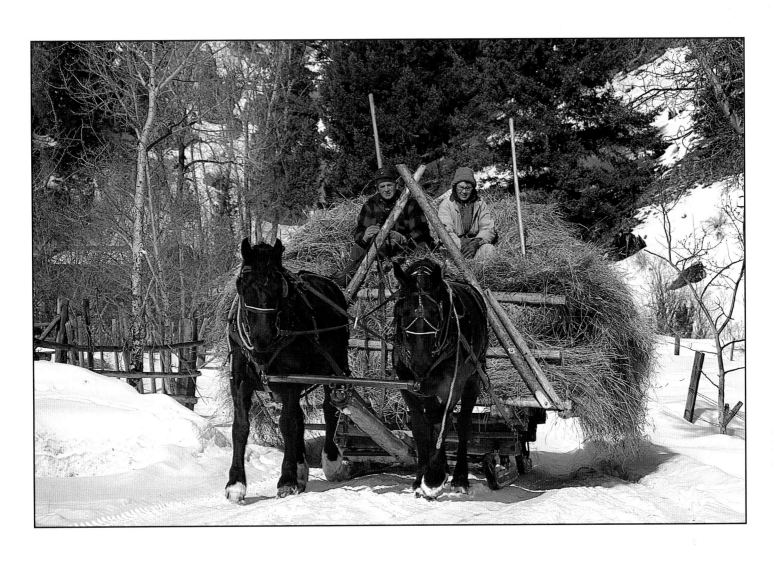

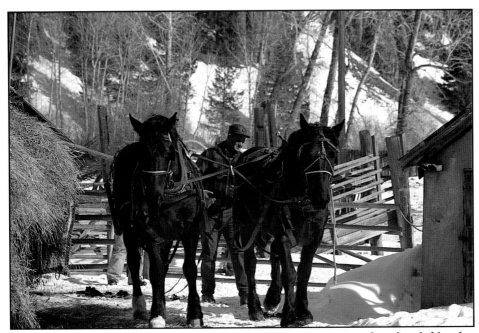

A hitch of blacks

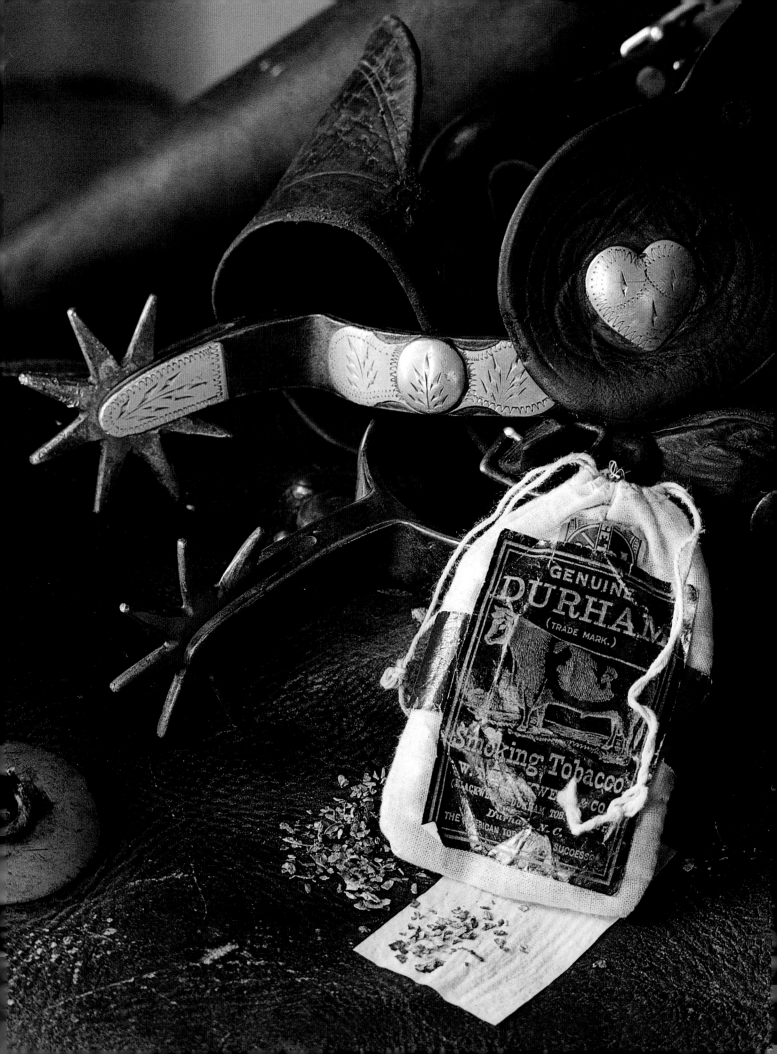

The makin's in Bull Durham sacks.

It's great horned owls
A heron's catch
And blue grouse eggs about to hatch.
It's loggin' rigs
A gentle rain
A sunlit field of ripened grain.

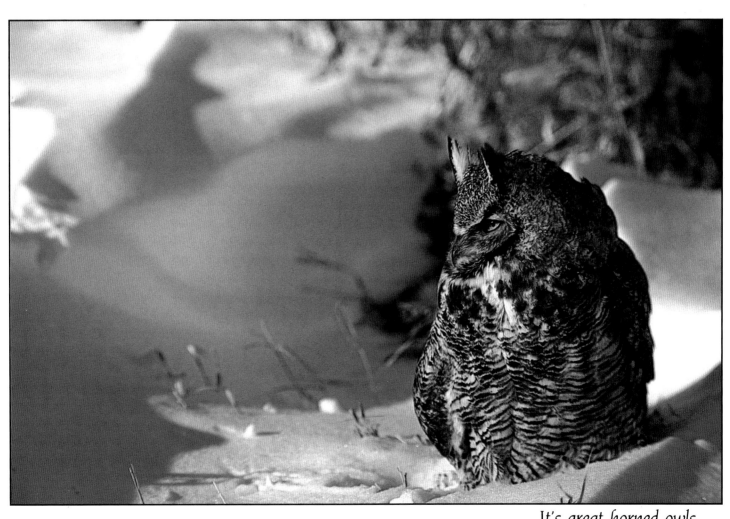

It's great horned owls

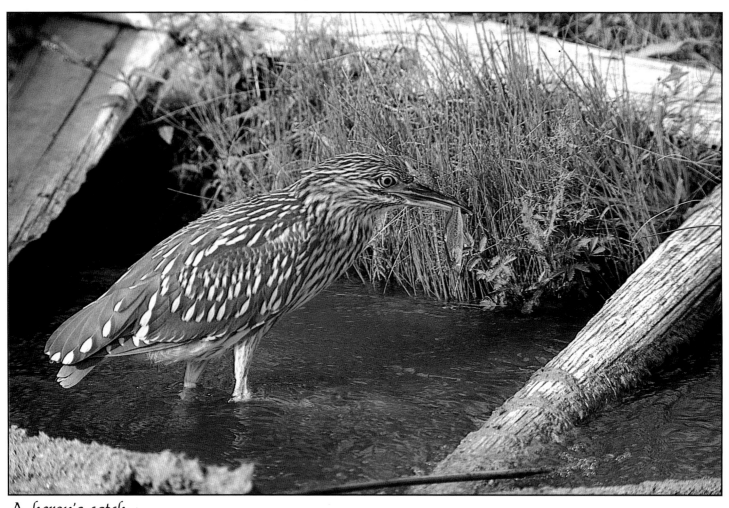

A heron's catch

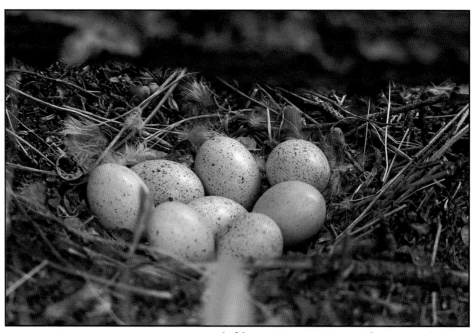

And blue grouse eggs about to hatch.

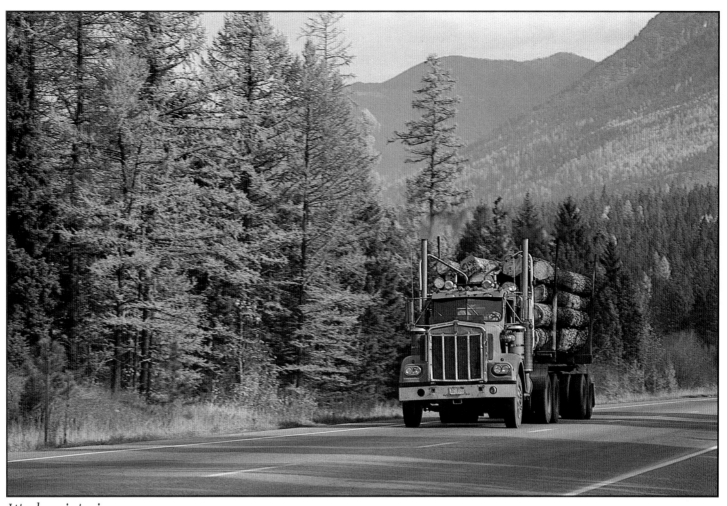

It's loggin' rigs

A gentle rain

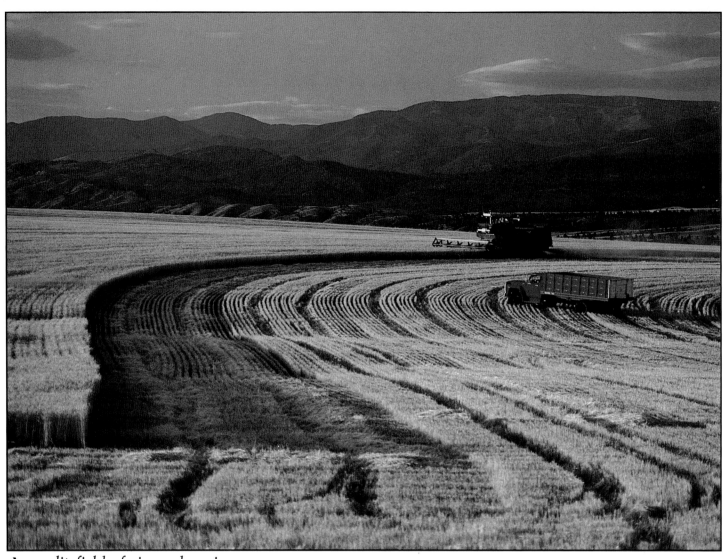

A *sunlit field of ripened grain.*

It's shootin' stars
A snowswept ridge
A river crossed without a bridge.
It's well worn chaps
And mule deer's eyes
A champion steer that takes the prize.

It's shootin' stars

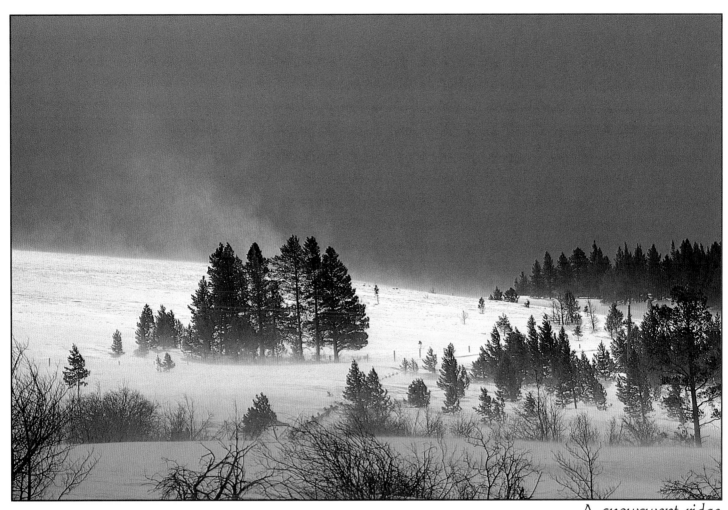

A snowswept ridge

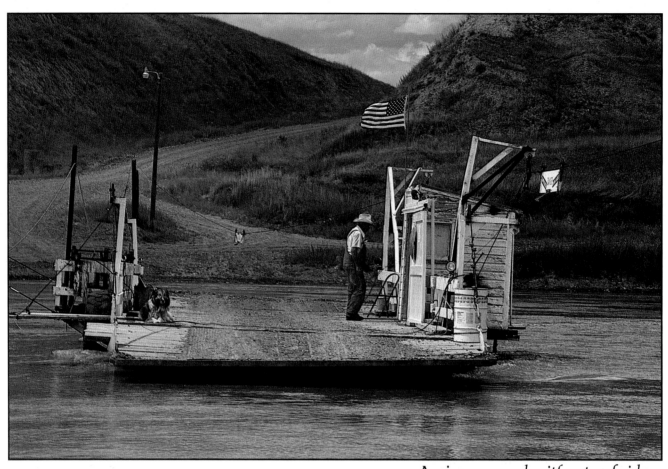

A river crossed without a bridge.

It's well worn chaps

And mule deer's eyes

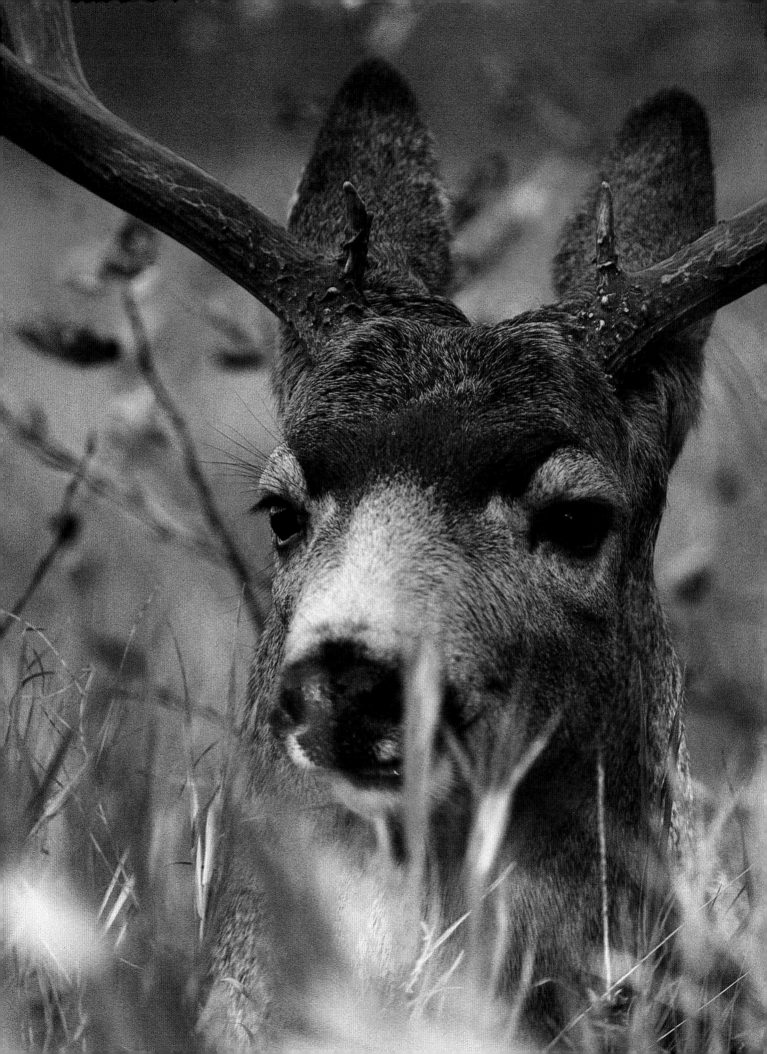

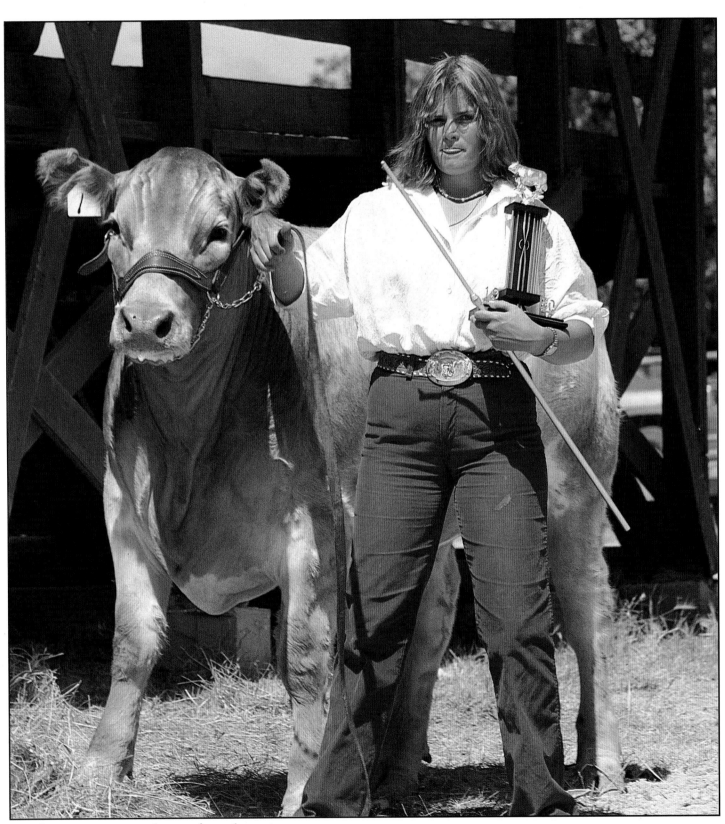

A *champion steer that takes the prize.*

It's crumblin' kilns
A red school house
And, struttin' proud, an old sage grouse.
It's bison herds
And dreams long gone
A portrait of a whistlin' swan.

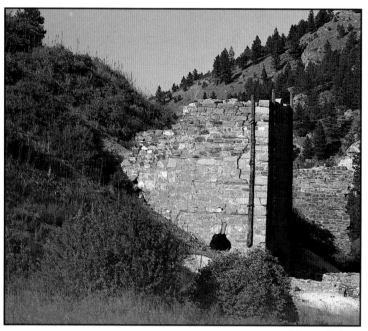

It's crumblin' kilns

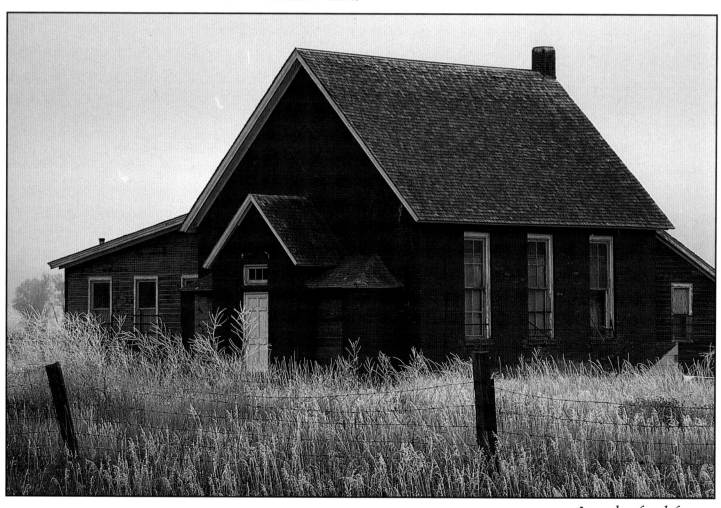

A red school house

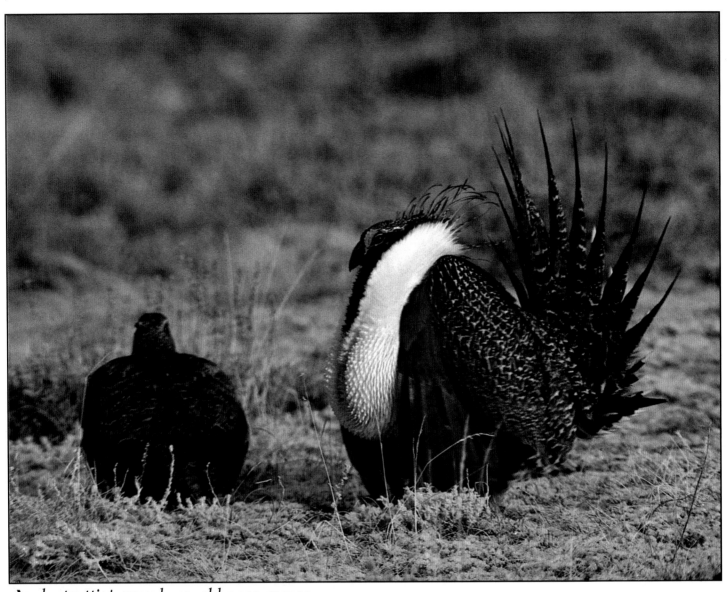

And, struttin' proud, an old sage grouse.

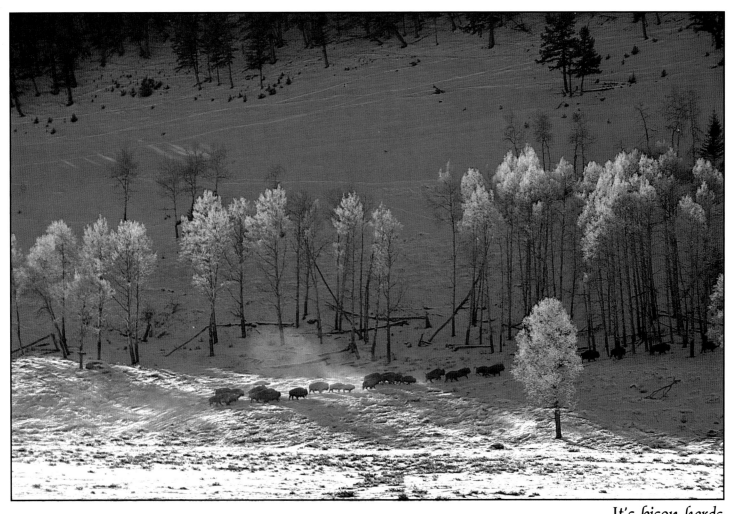

It's bison herds

And dreams long gone.

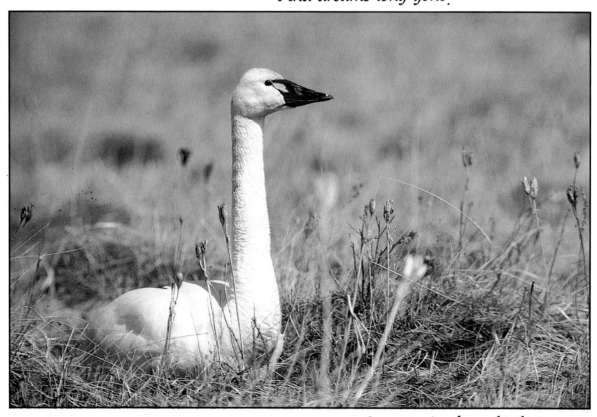

A portrait of a whistlin' swan.

It's wilderness
Abandoned mines
A winter sun that barely shines.
It's frost flocked trees
A sundown team
The answer to a hunter's dream.

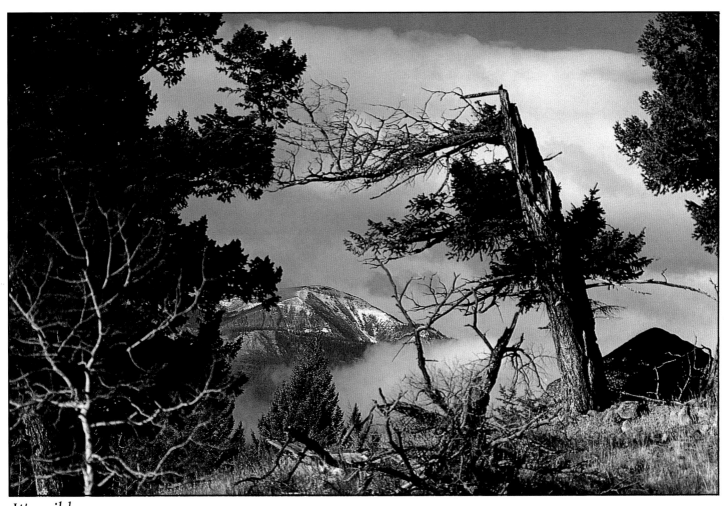

It's wilderness

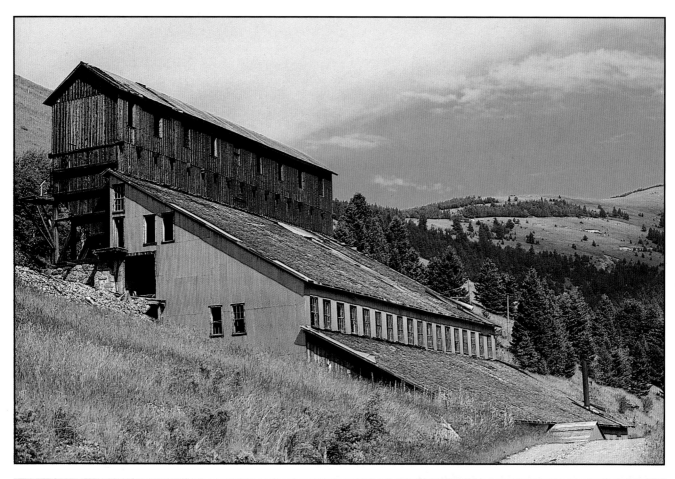

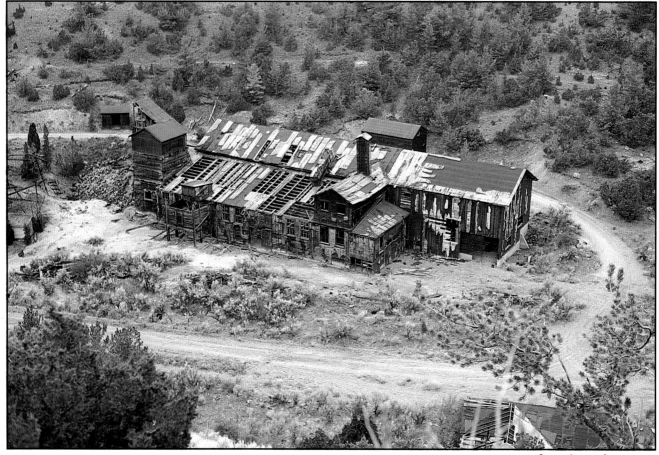

Abandoned mines

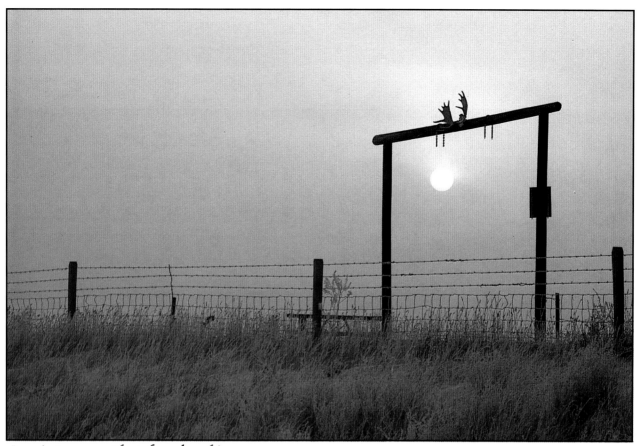

A *winter sun that barely shines.*

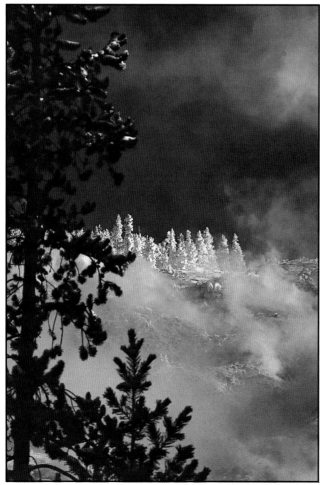

It's frost flocked trees

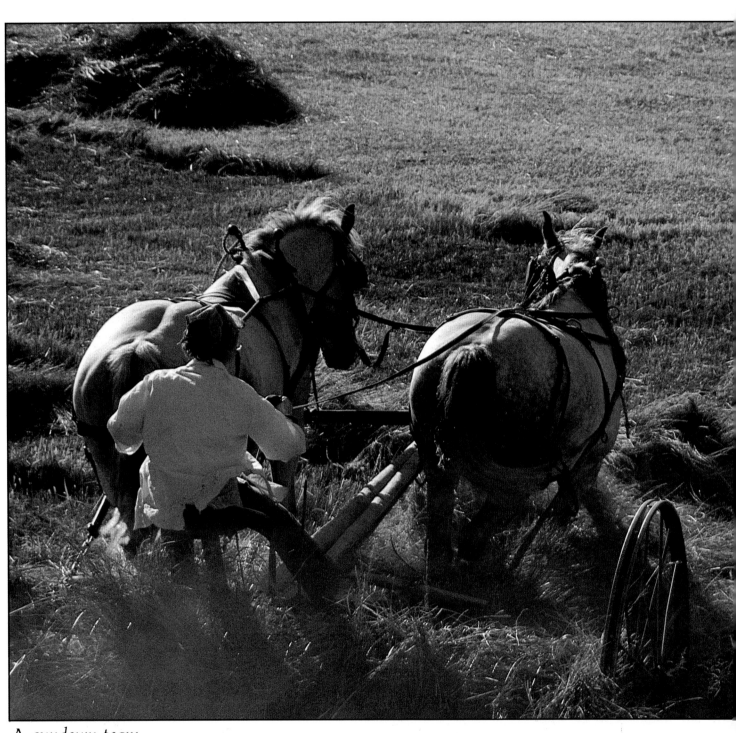

A *sundown team*

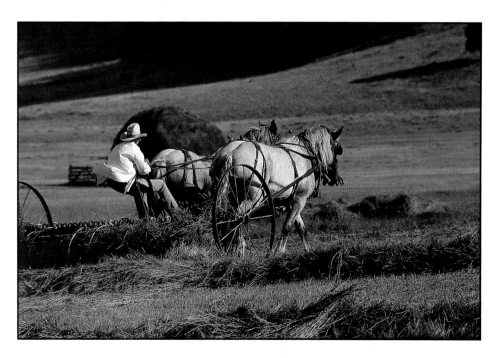

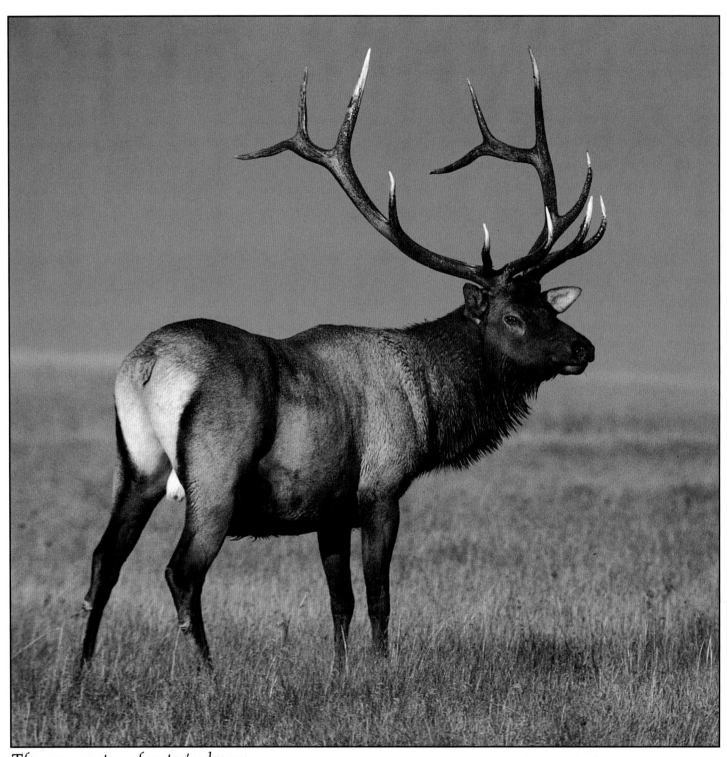

The answer to a hunter's dream.

It's cottonwoods
And goldeneye
And snow geese back to fill the sky.
It's heelin' dogs
And loadin' chutes
And Charlie Russell's high square buttes.

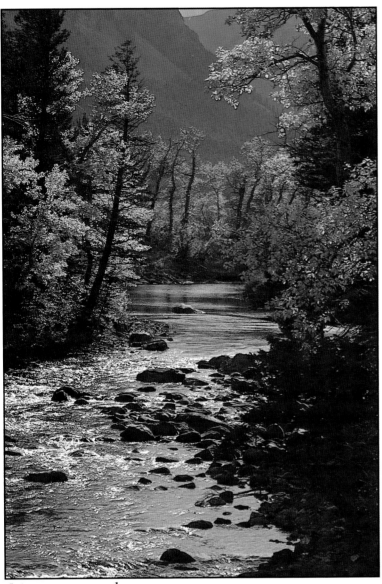

It's cottonwoods

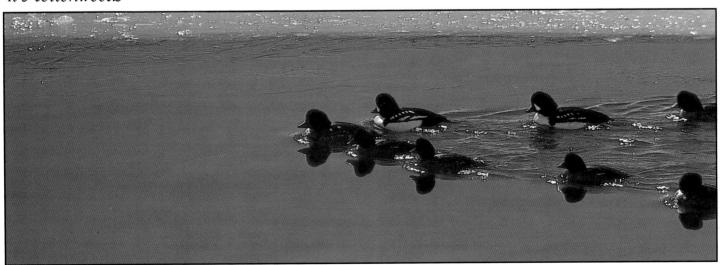

And goldeneye

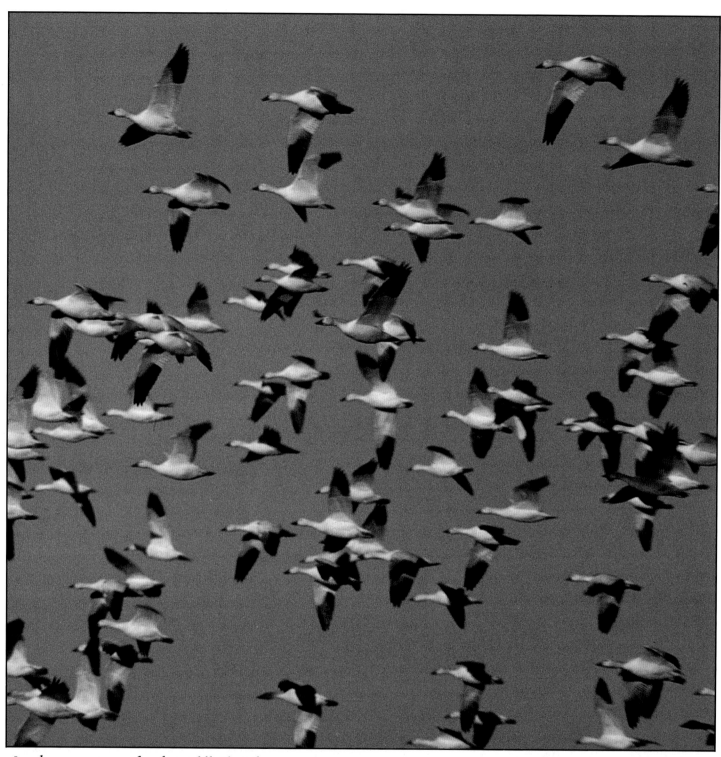

And snow geese back to fill the sky.

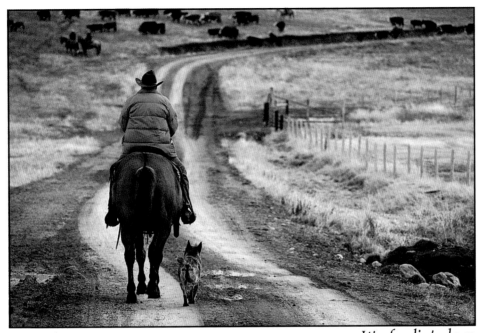

It's heelin' dogs

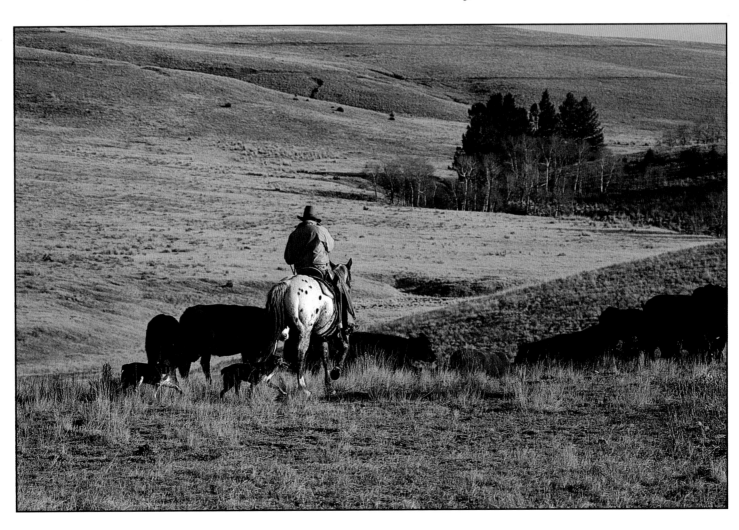

And loadin' chutes

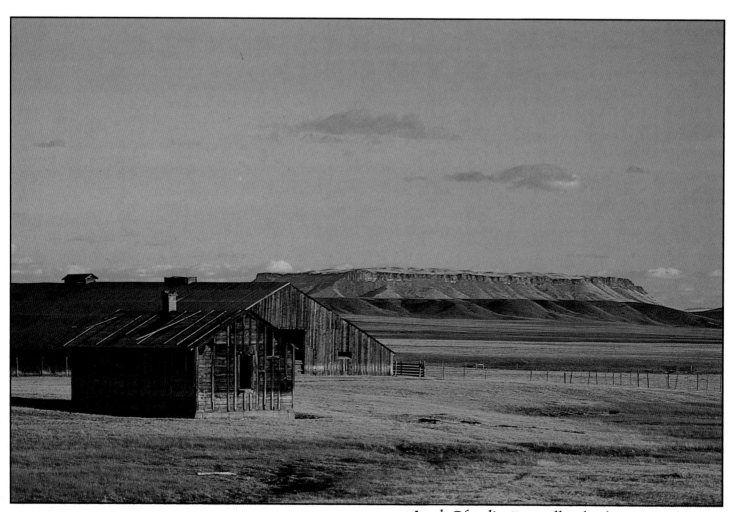

And Charlie Russell's high square buttes.

It's antelope
And huge snow plows
And cuttin' out the heavy cows.
An eagle's watch
Fawns sittin' tight
The lonesome sound of geese at night.

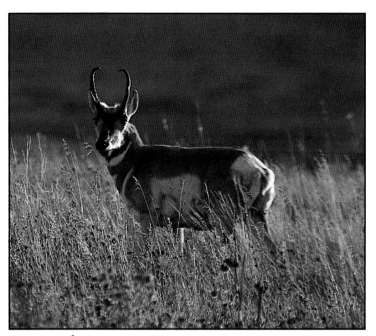

It's antelope

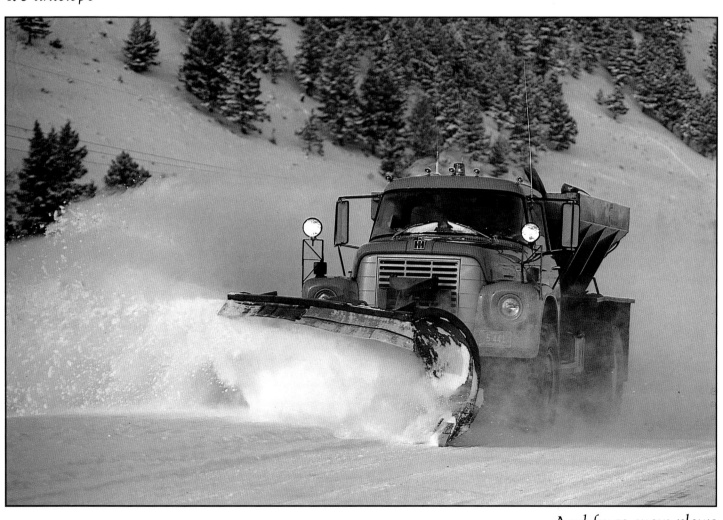

And huge snow plows

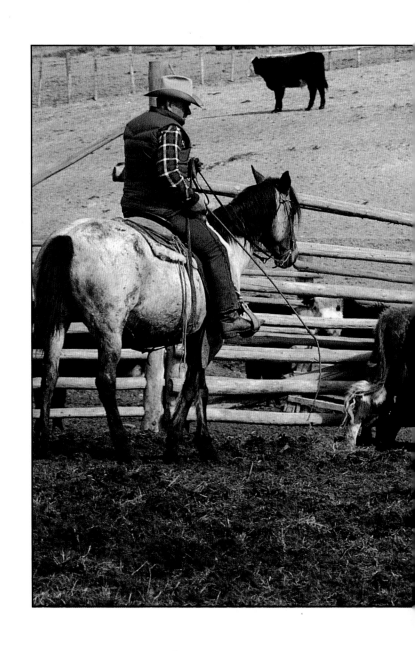

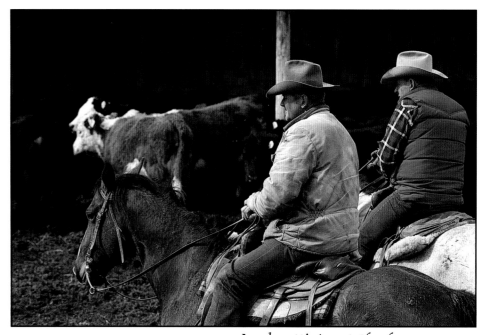

And cuttin' out the heavy cows.

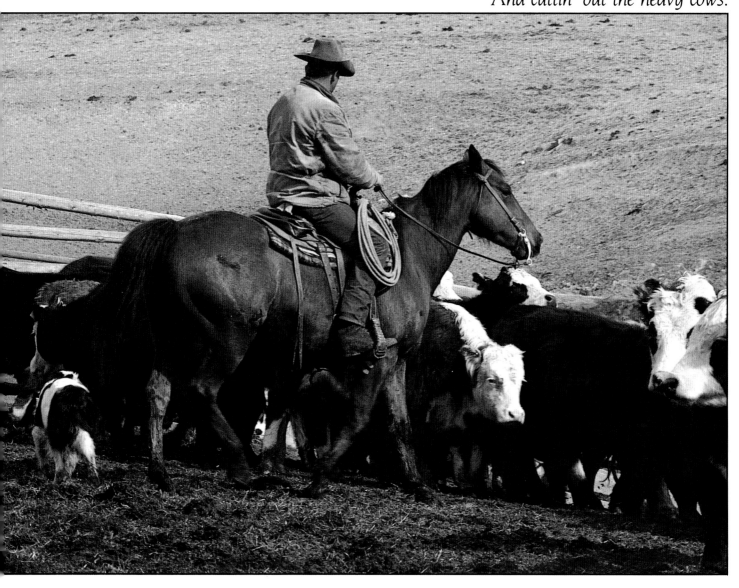

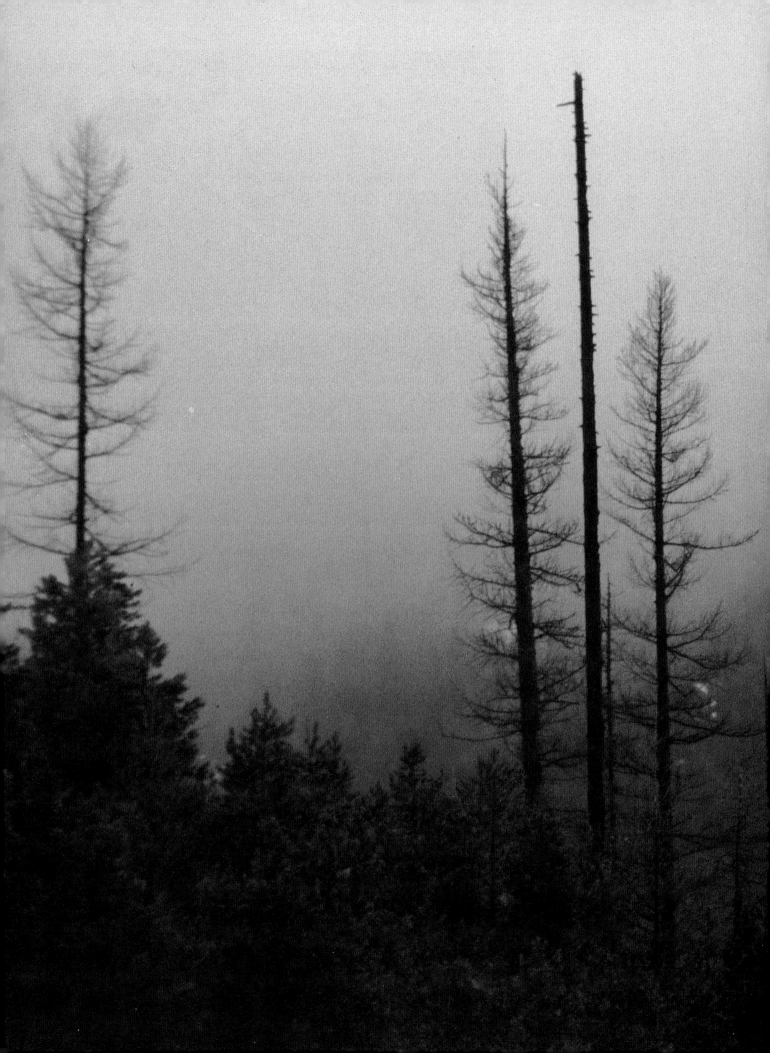

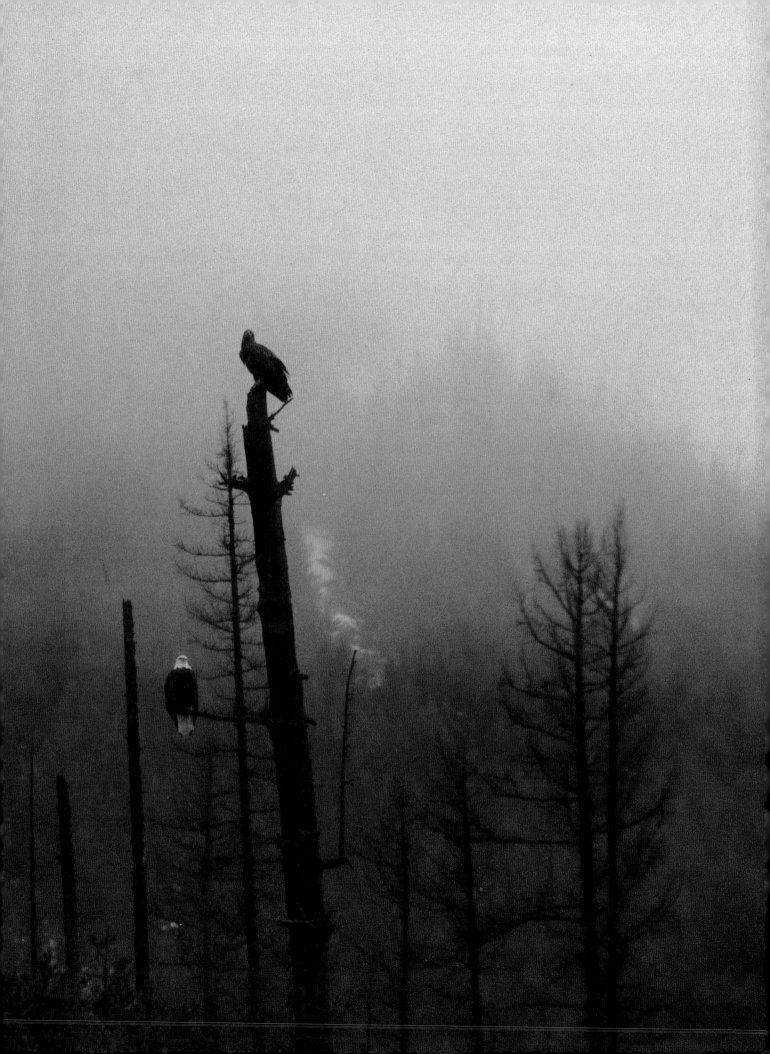

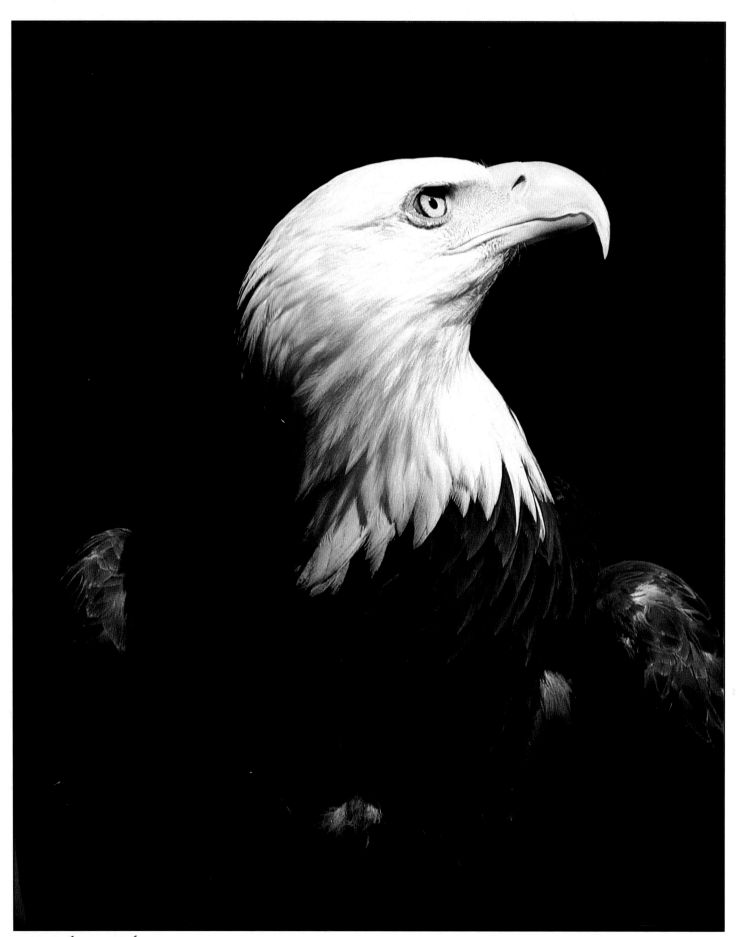

An eagle's watch

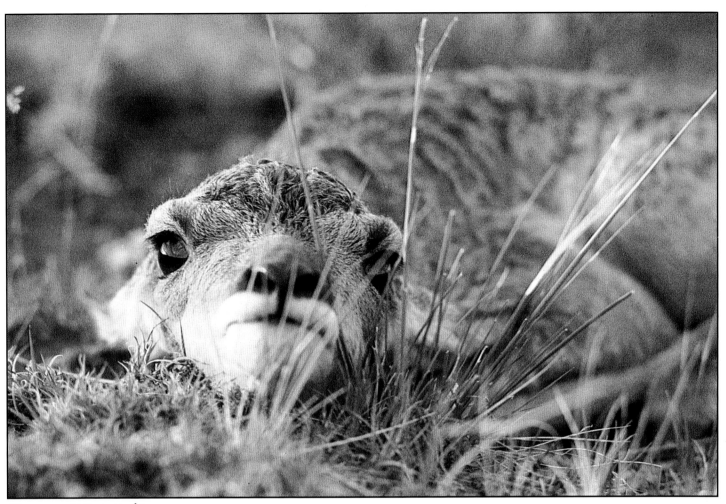

Fawns sittin' tight

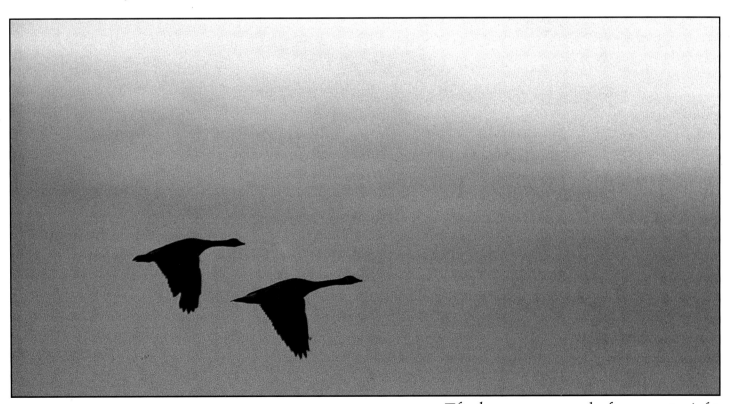

The lonesome sound of geese at night.

It's rainbow's end
And threshing bees
And quick red squirrels that lunch in trees.
It's shining lakes
And cold duck blinds
And bullet holes in frosted signs.

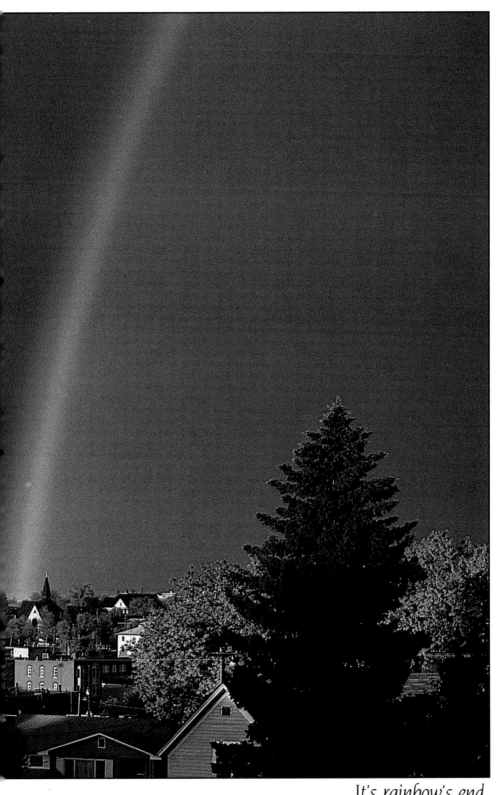

It's rainbow's end

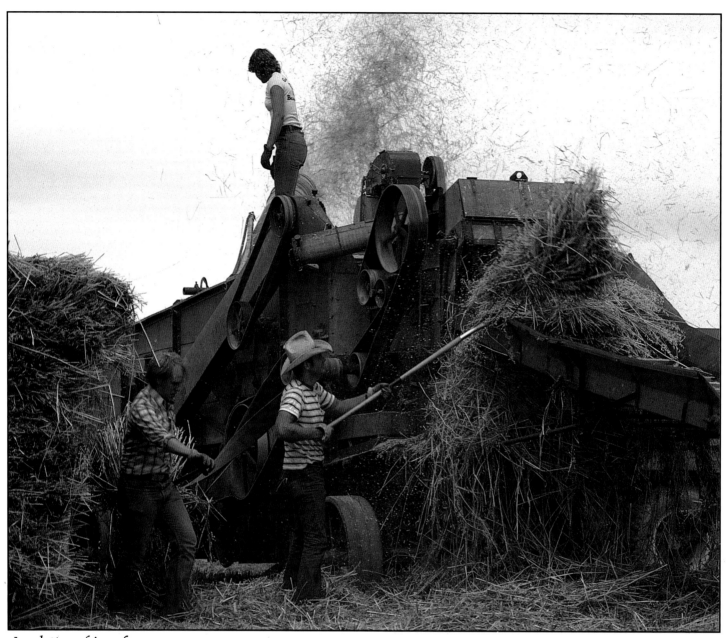

And threshing bees

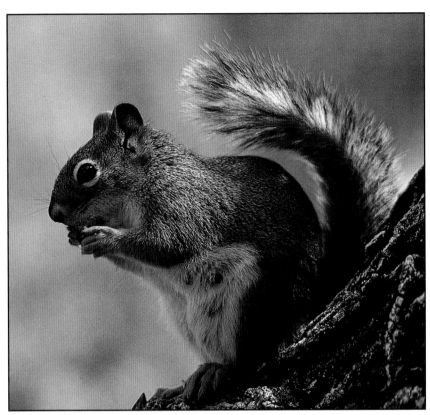

And quick red squirrels that lunch in trees.

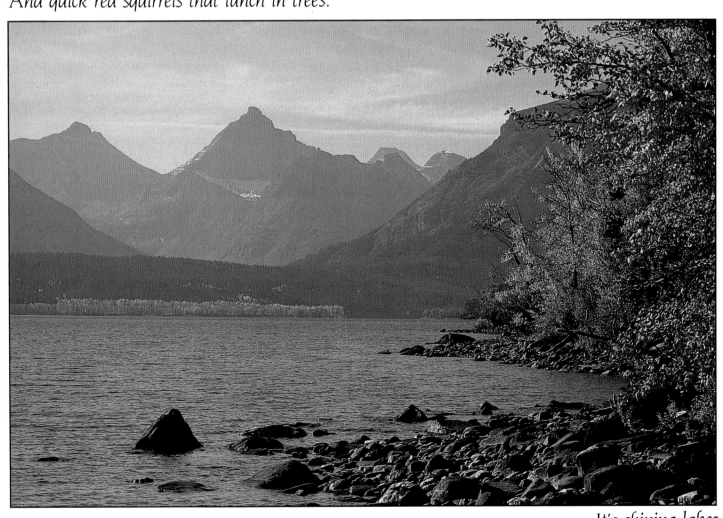

It's shining lakes

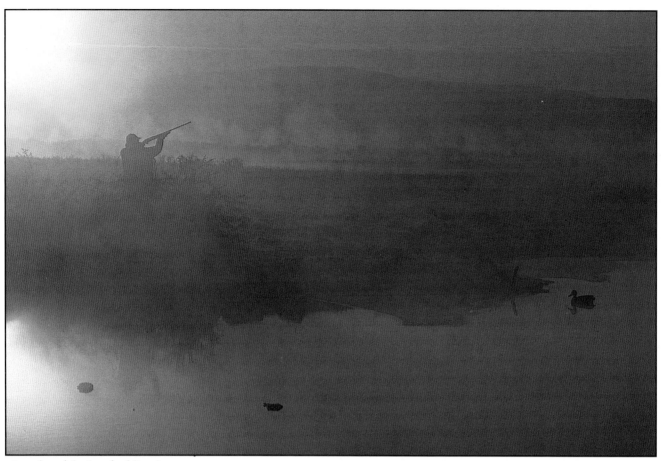

And cold duck blinds

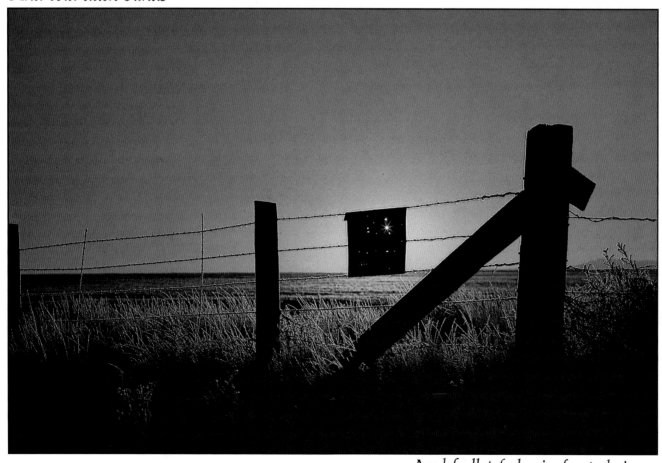

And bullet holes in frosted signs.

It's silhouettes
And tracks in snow
An evening on a high plateau.
It's closin' gates
A wooly flock
A mantled ground squirrel on a rock.

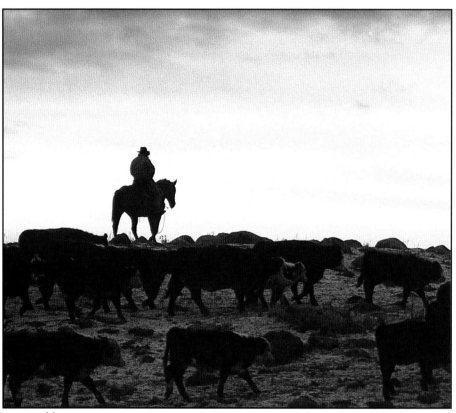

It's silhouettes

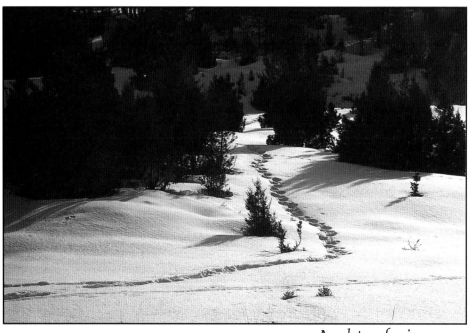

And tracks in snow

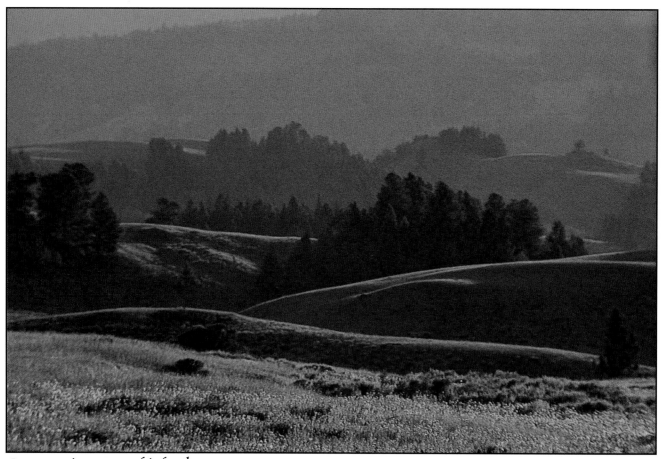

An evening on a high plateau.

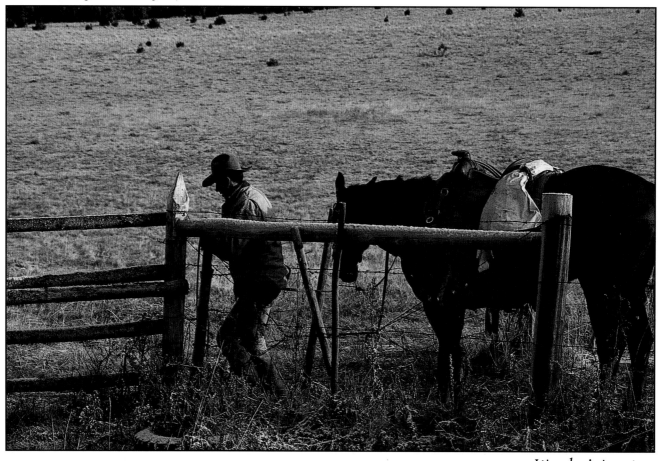

It's closin' gates

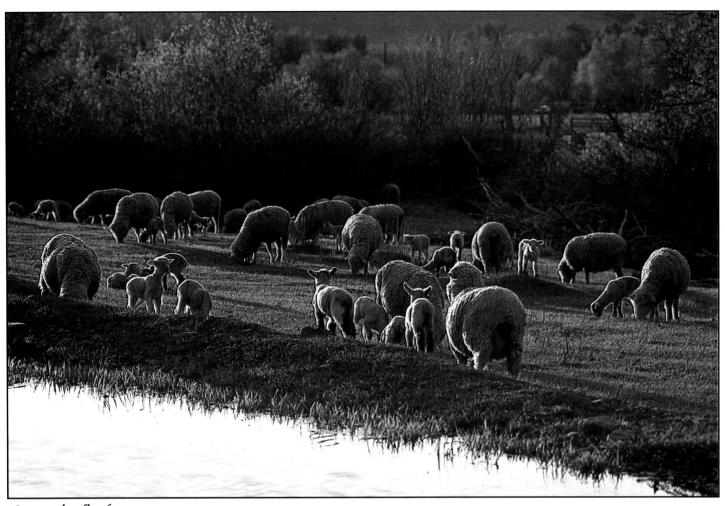

A *wooly flock*

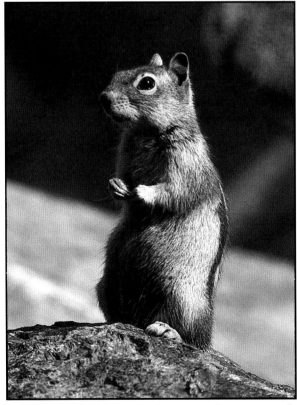

A *mantled ground squirrel on a rock.*

It's ridin' fence

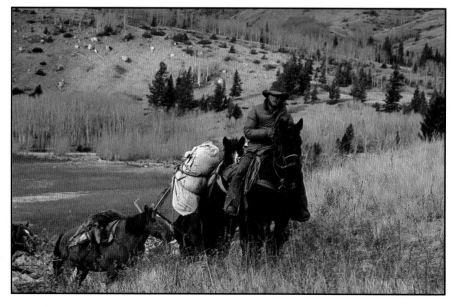

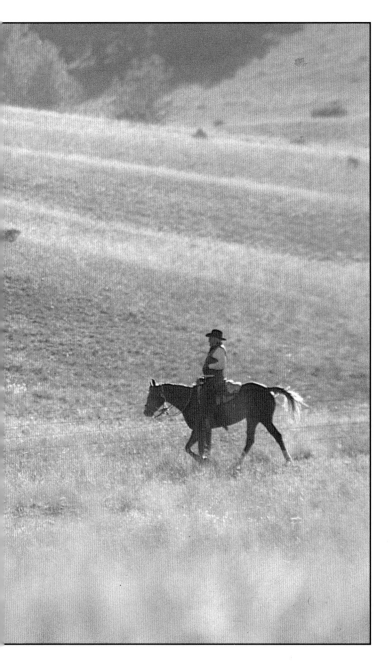

It's ridin' fence
A packer's string
And flowers so bright they seem to sing.
It's mountain goats
And hay new mowed
A pickup on a dusty road.

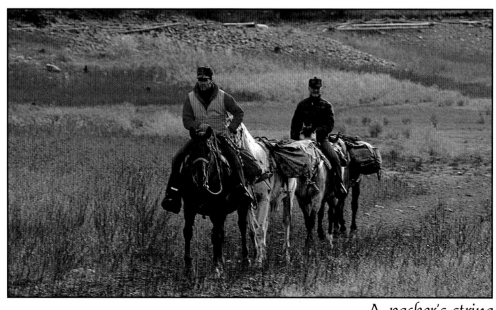

A packer's string

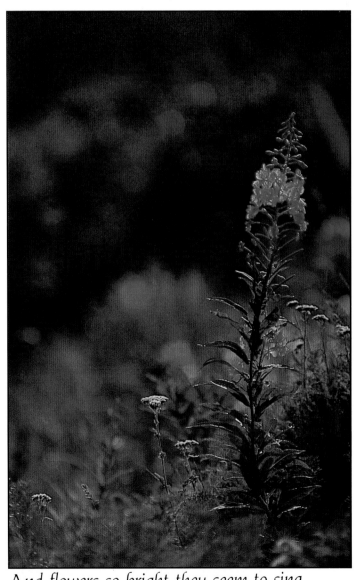

And flowers so bright they seem to sing.

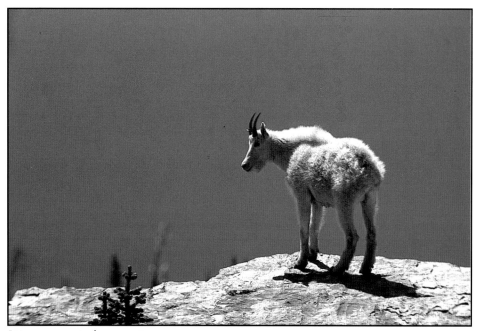

It's mountain goats

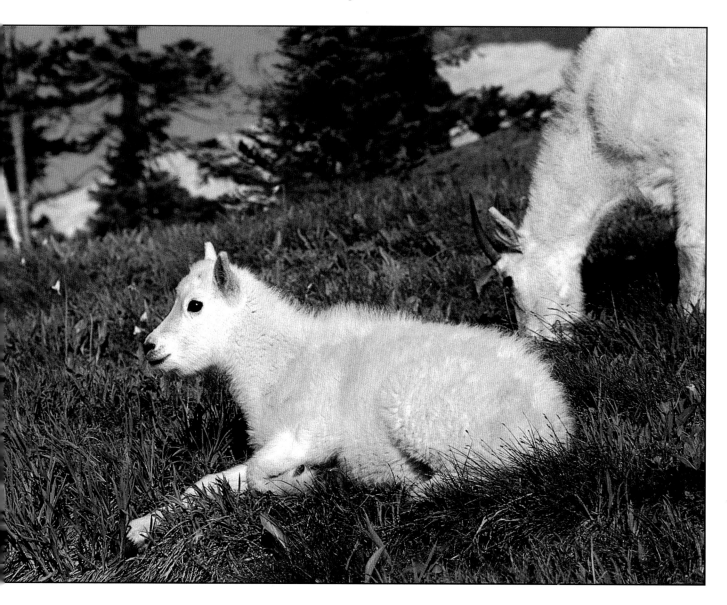

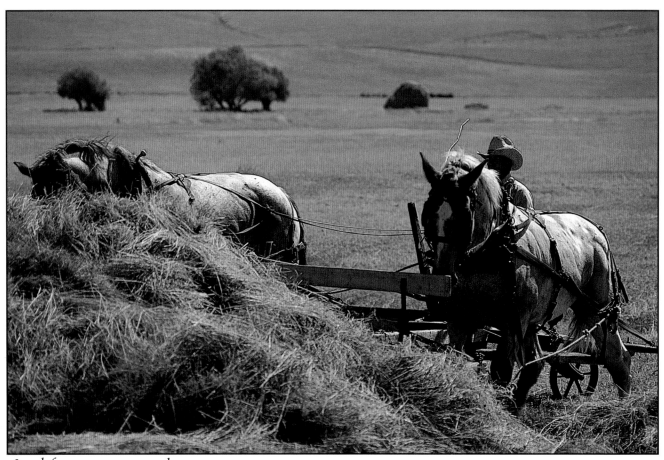

And hay new mowed

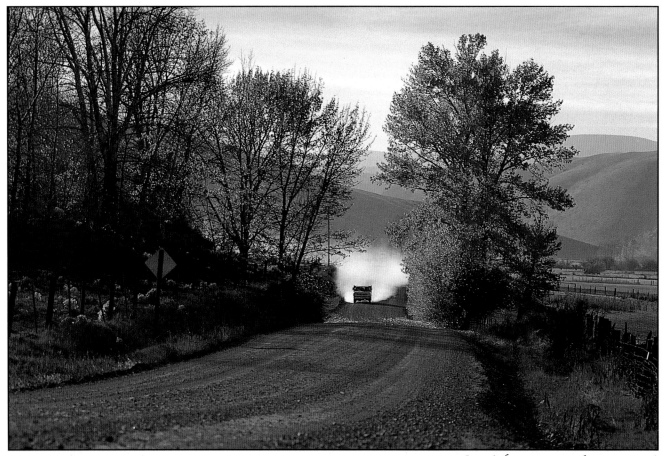

A pickup on a dusty road.

It's workin' hands
A river's course
And irrigatin' on a horse.
It's fishermen
And hook jawed trout
And prairie dogs just peekin' out.

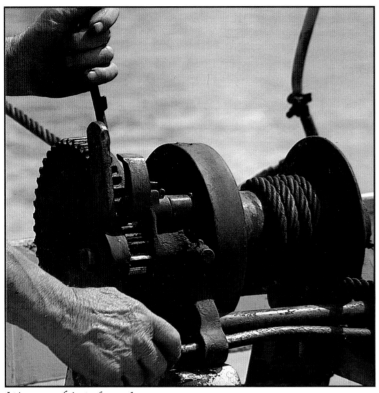

It's workin' hands

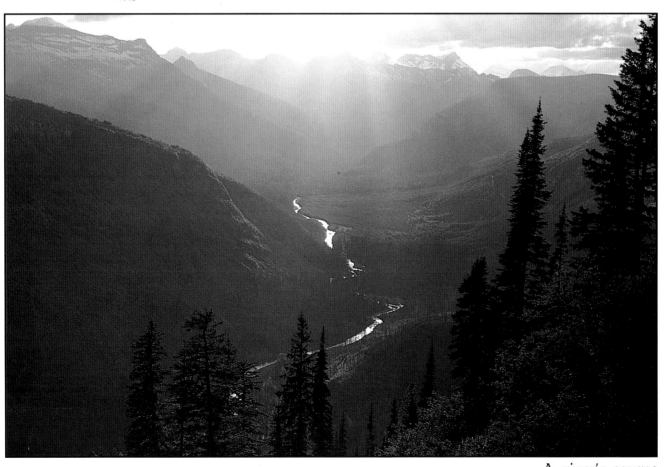

A river's course

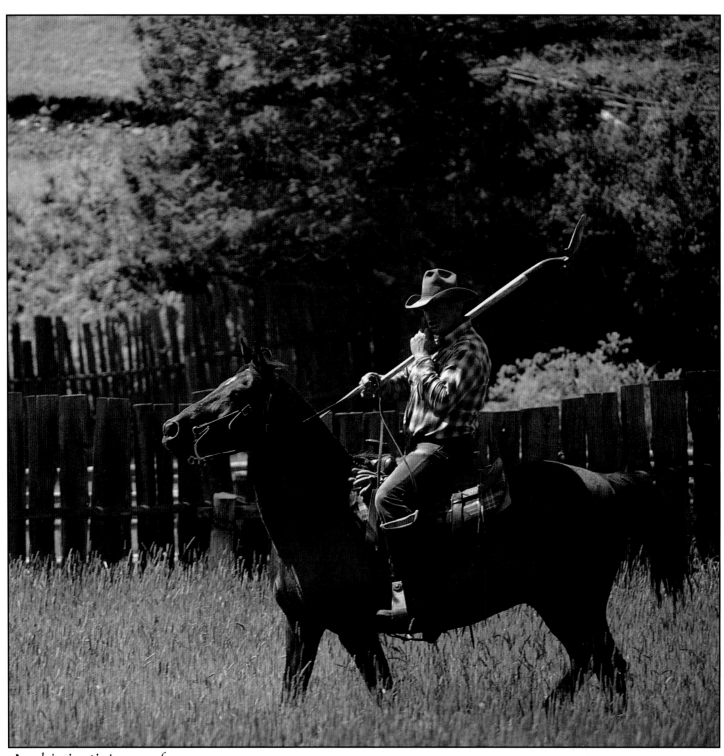

And irrigatin' on a horse.

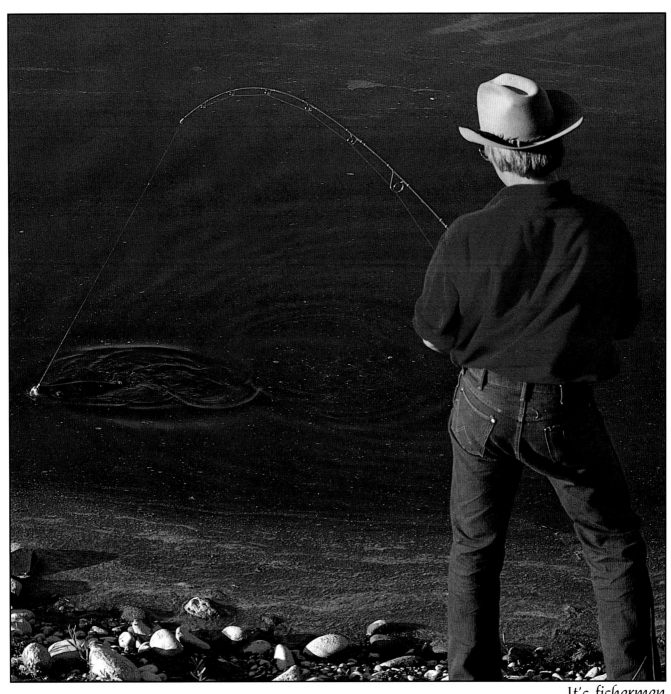

It's fishermen

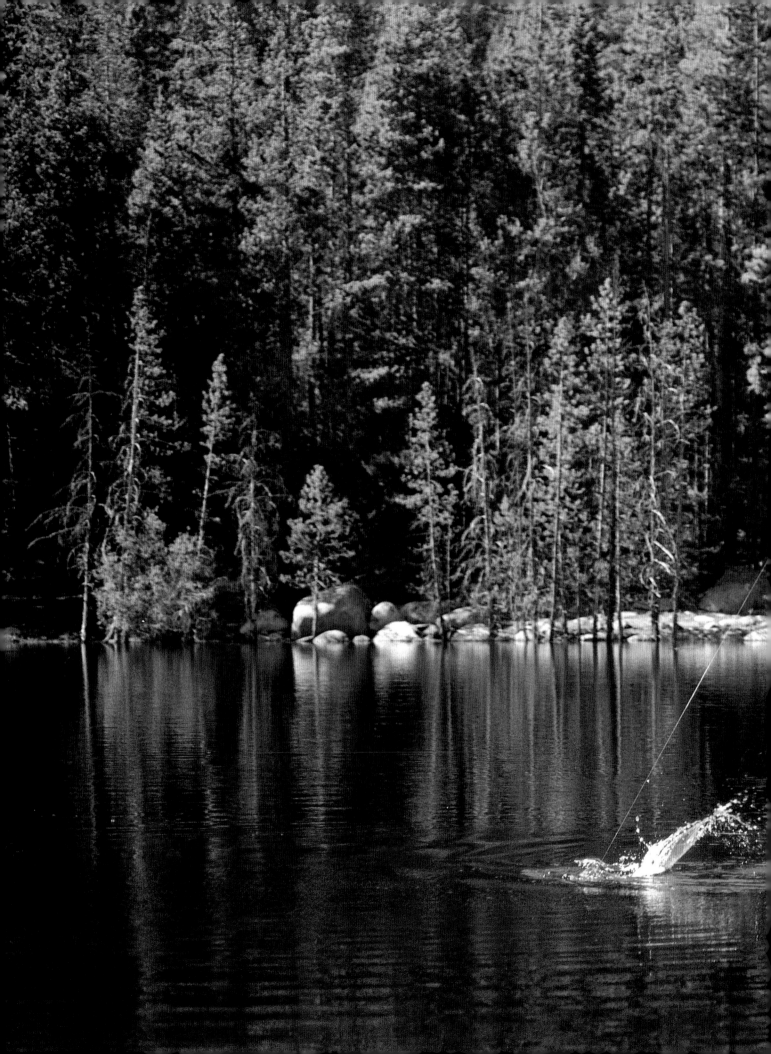

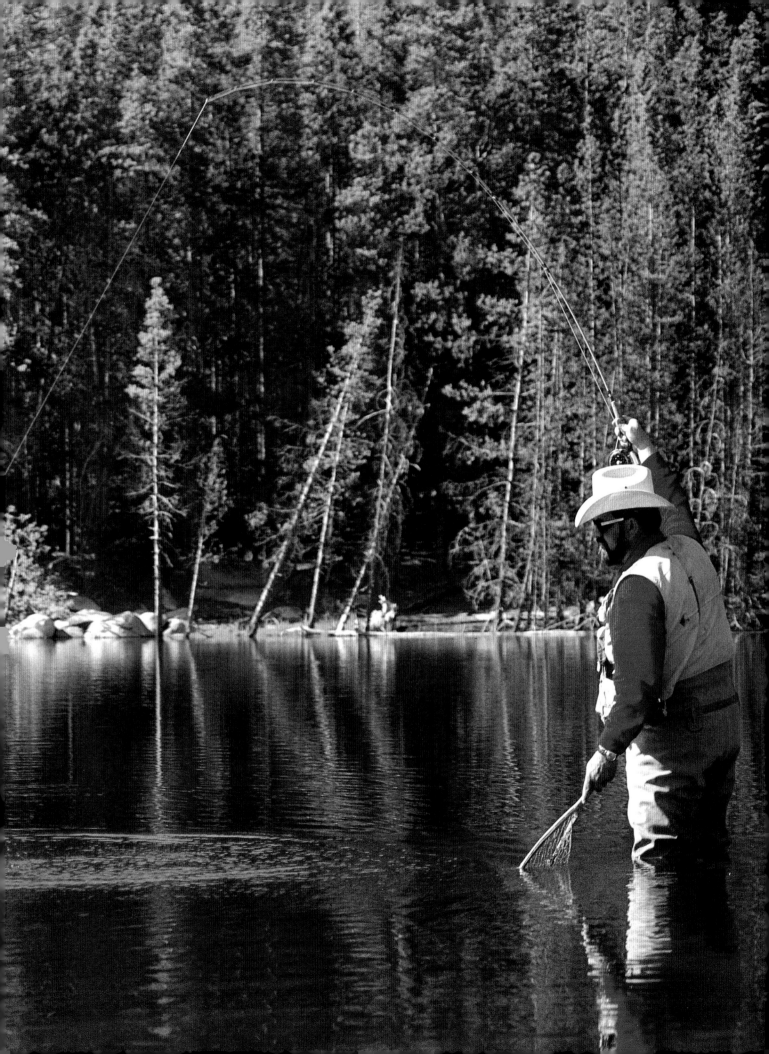

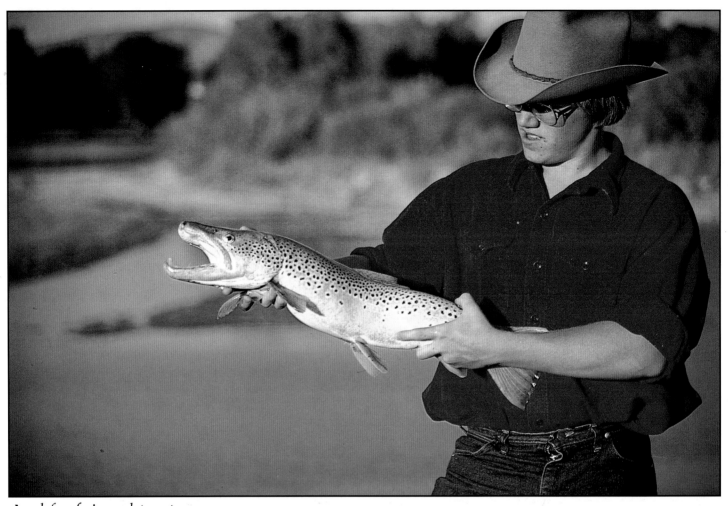

And hook jawed trout

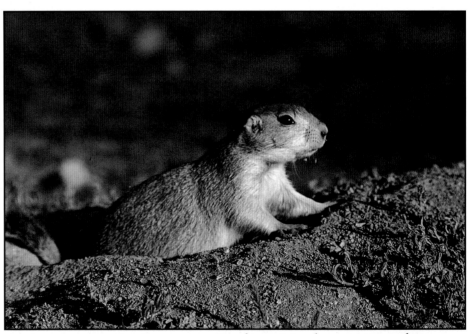

And prairie dogs just peekin' out.

It's tumbleweeds
A capitol dome
A momma osprey comin' home.
It's ptarmigan
A hay sled full
And snowfall on a blizzard bull.

It's tumbleweeds

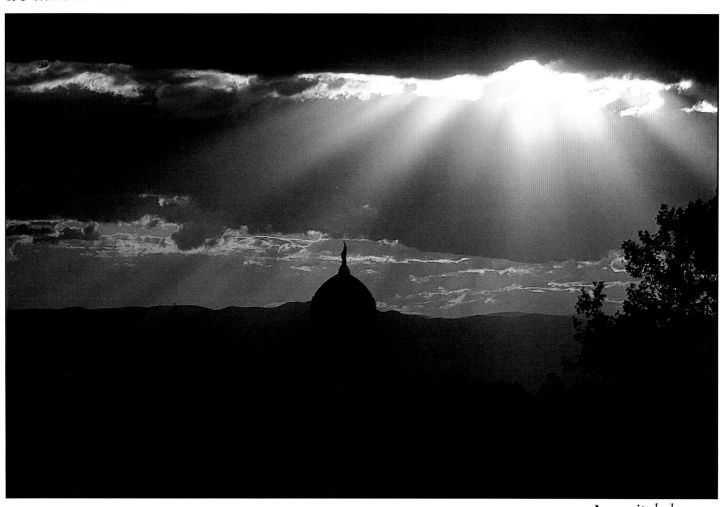

A capitol dome

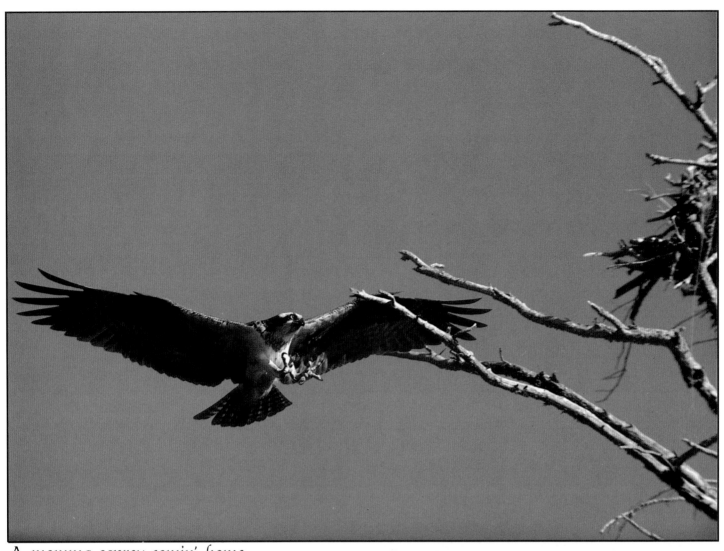

A momma osprey comin' home.

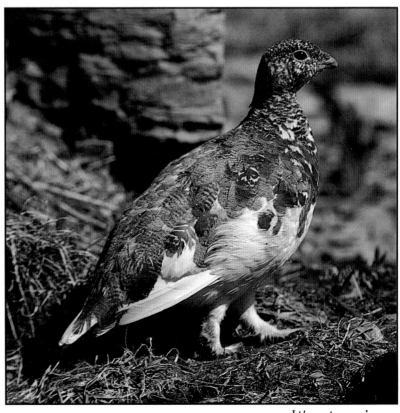

It's ptarmigan

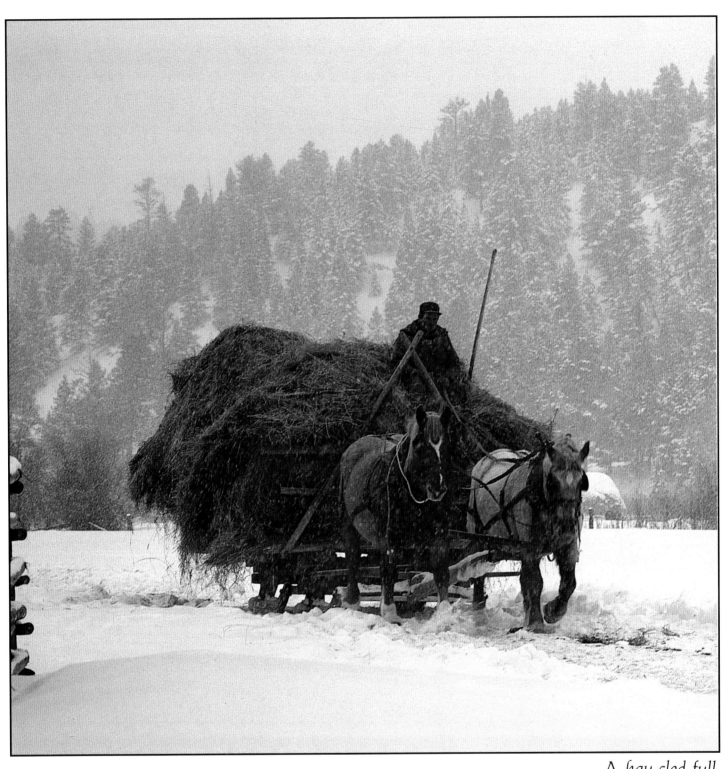

A hay sled full

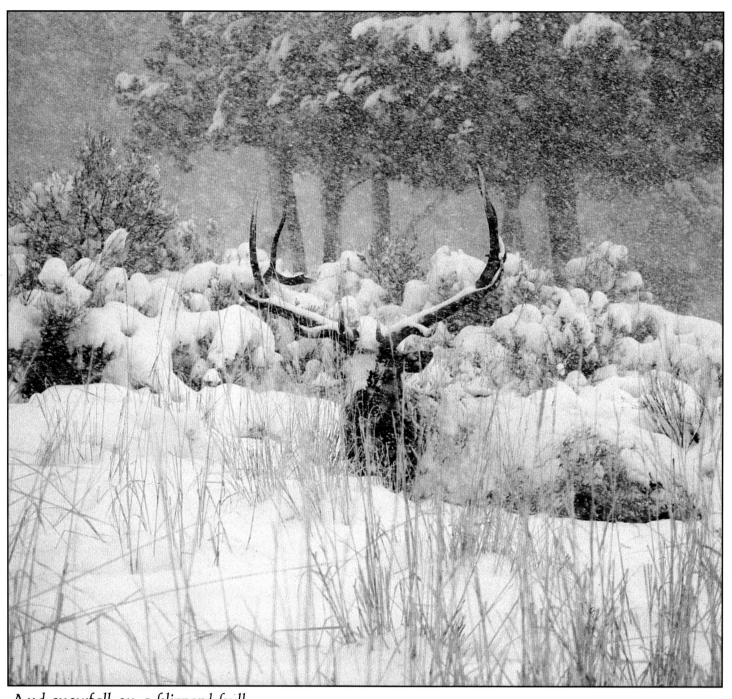

And snowfall on a blizzard bull.

It's marmot kings
And final turns
A fireset when the forest burns.
It's pickup men
A cactus flower
And, on a hill, an old firetower.

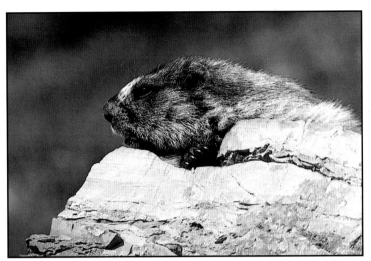

It's marmot kings

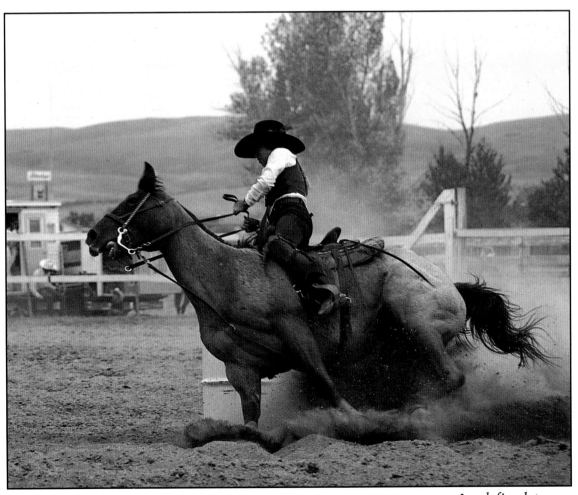

And final turns

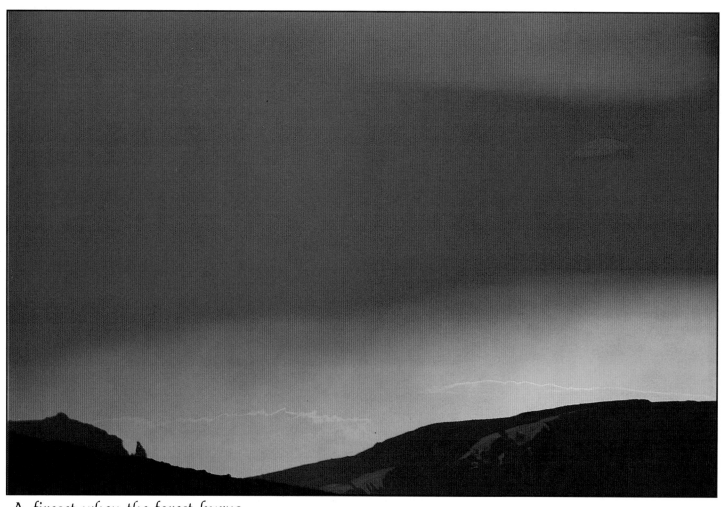

A *fireset* when the forest burns.

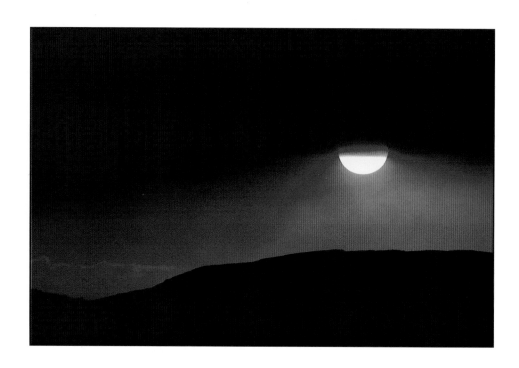

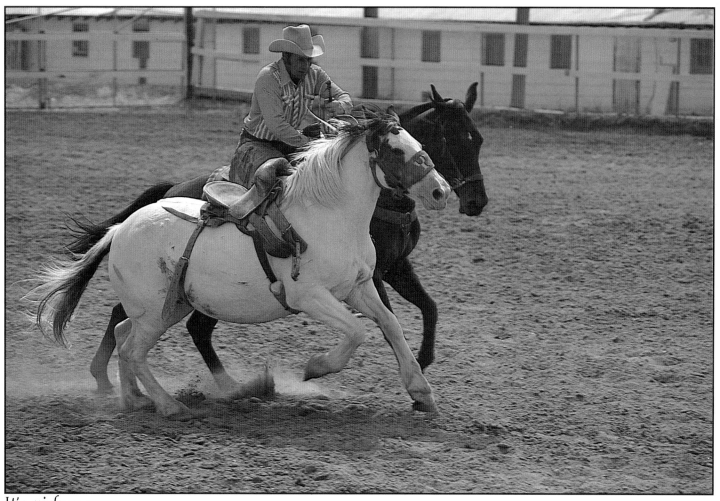

It's pickup men

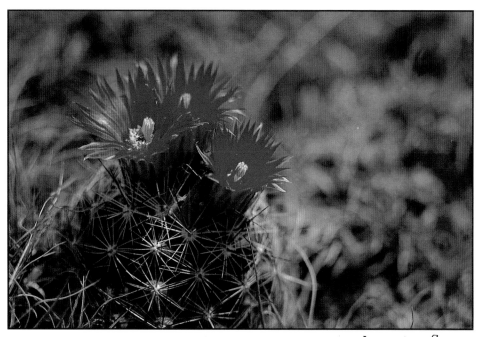

A cactus flower

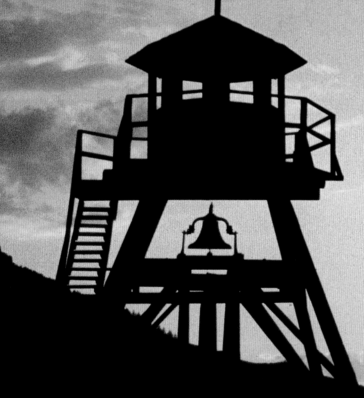

And, on a hill, an old firetower.

It's bitterroot
A country church
A chipmunk on a sagebrush perch.
It's winter elk
A cattle pen
And beargrass in a shaded glen.

It's bitterroot

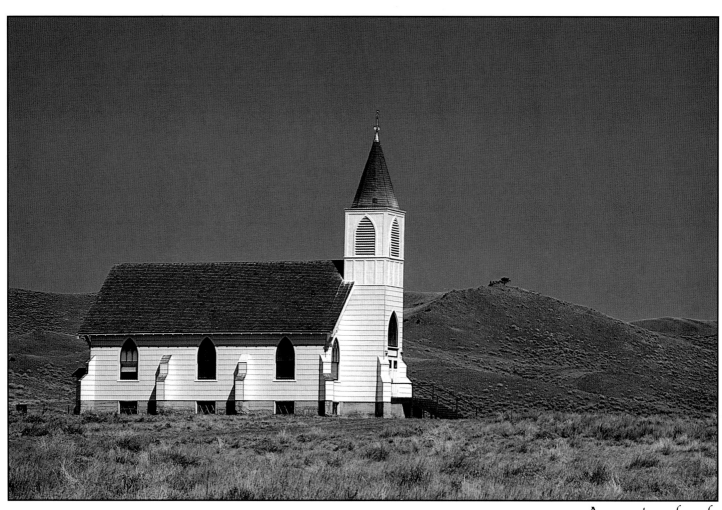

A country church

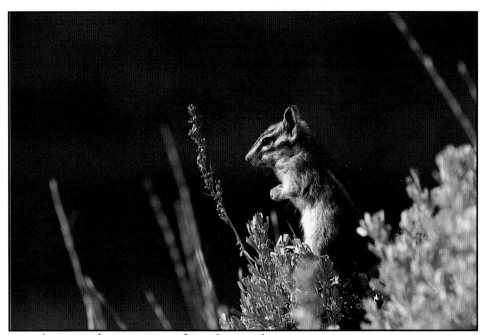

A chipmunk on a sagebrush perch.

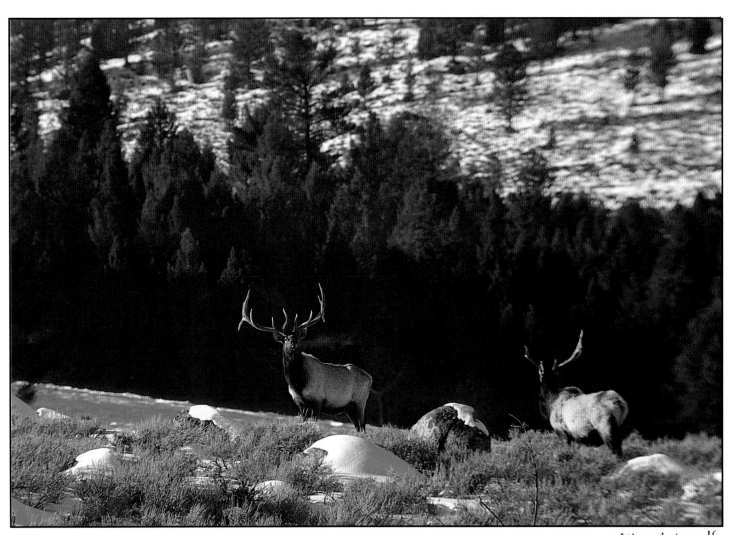

It's winter elk

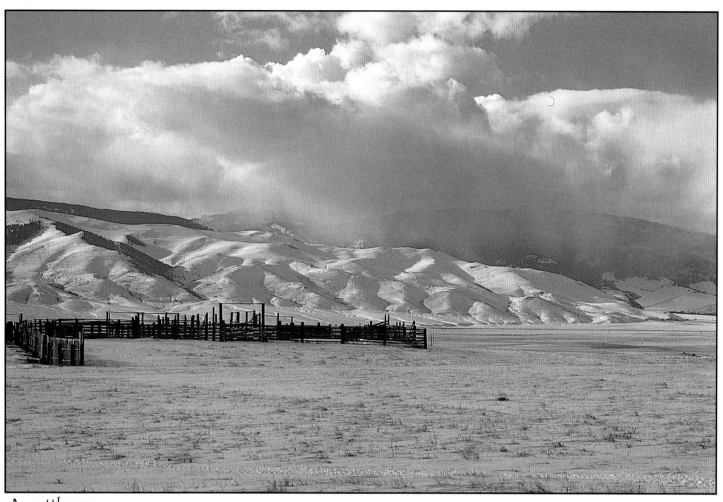

A cattle pen

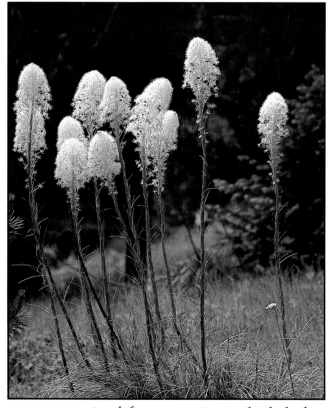

And beargrass in a shaded glen.

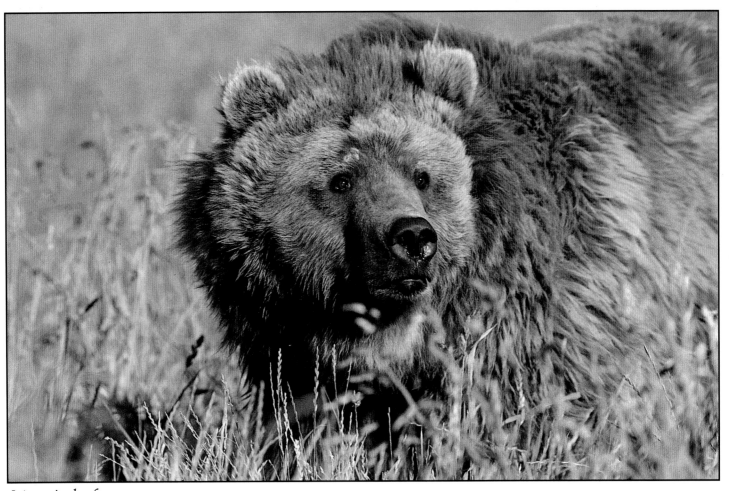

It's grizzly bears

It's grizzly bears
And snow capped peaks
And avocets with upturned beaks.
It's rodeos
And national parks
And wild free songs of meadowlarks.

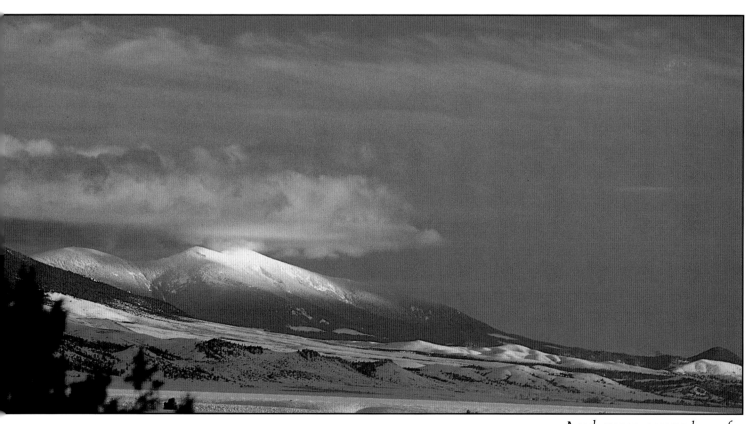

And snow capped peaks

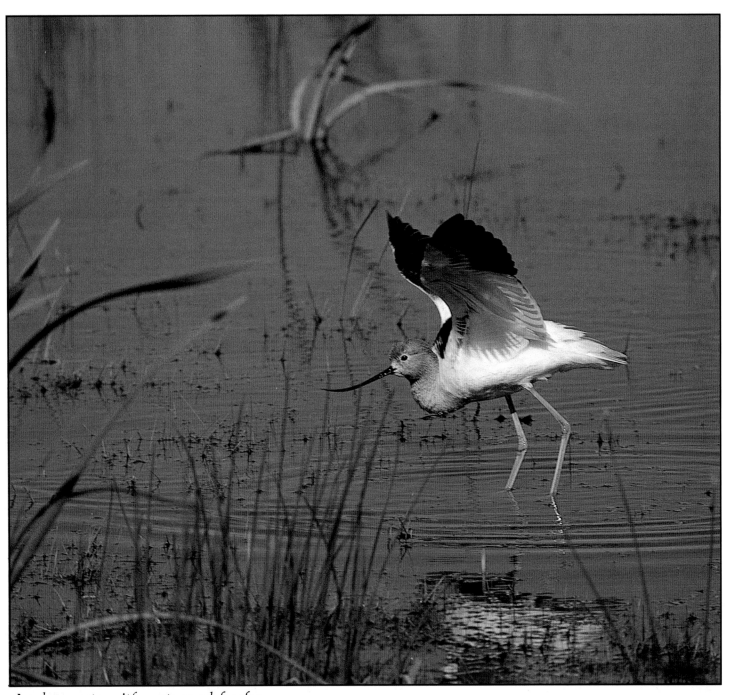

And avocets with upturned beaks.

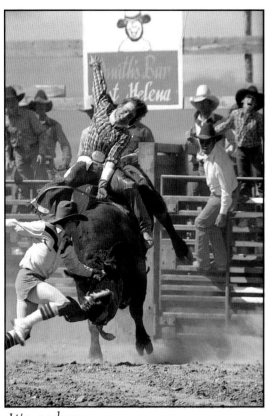

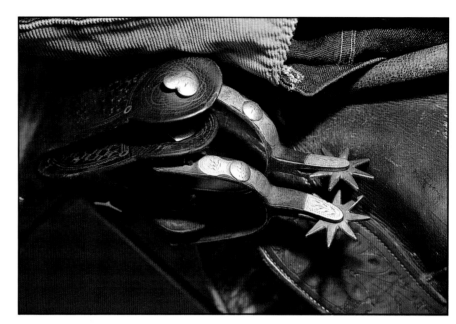

It's rodeos

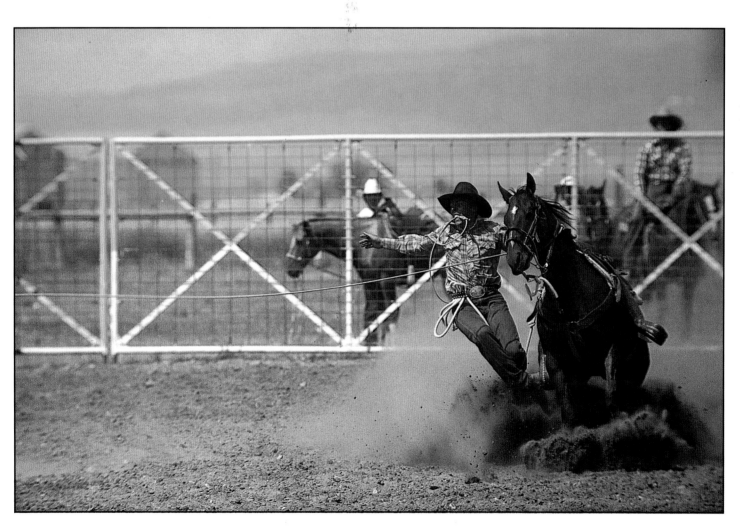

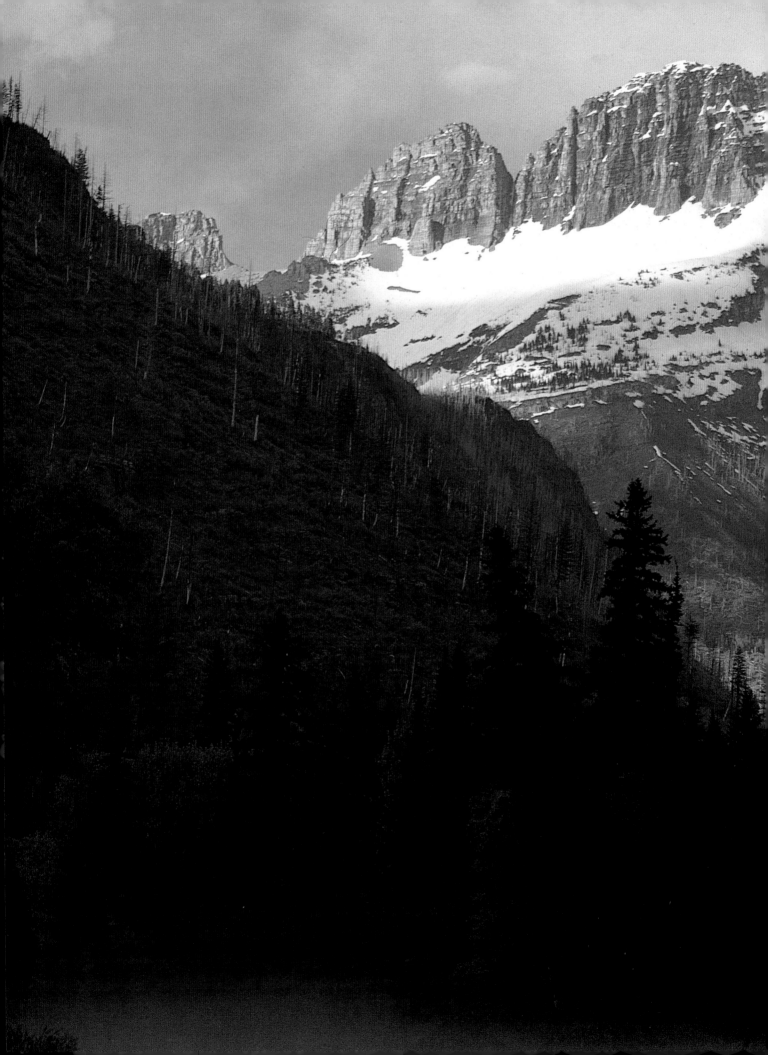

And national parks

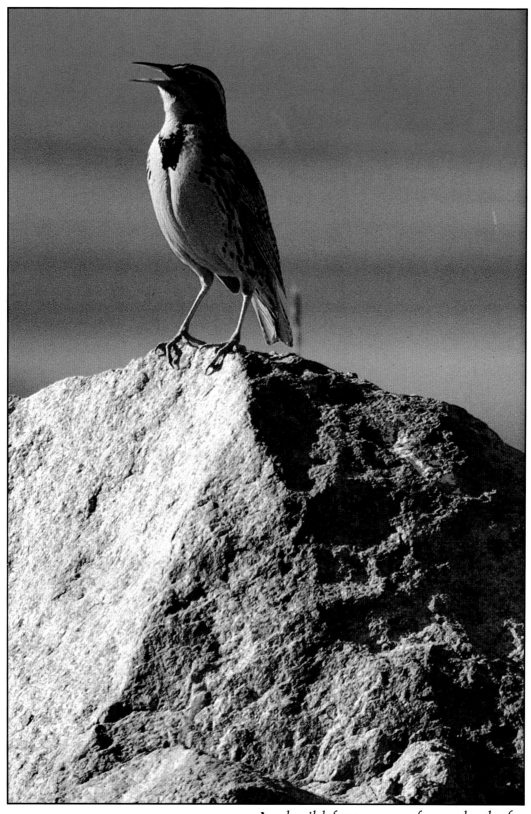

And wild free songs of meadowlarks.

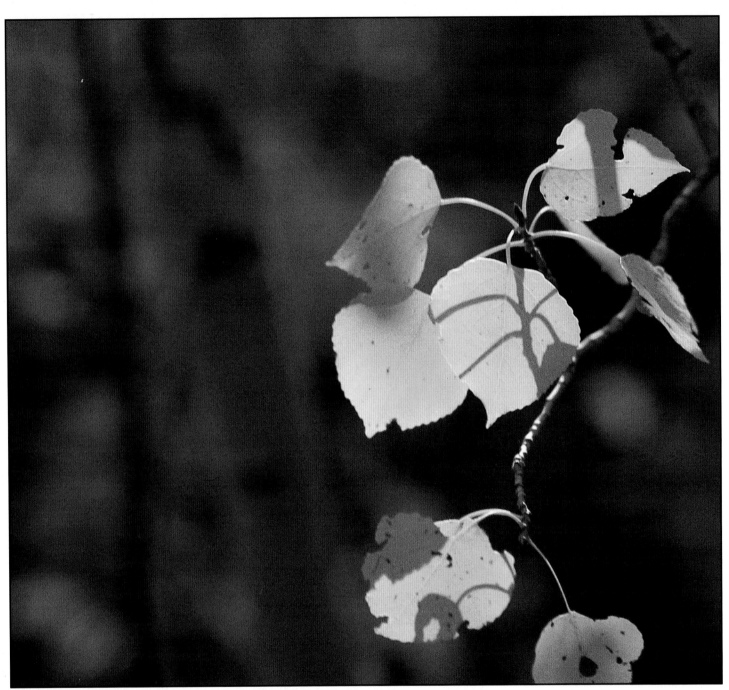

It's aspen leaves

It's aspen leaves
And early rides
And stackin' hay with beaverslides.
It's old homesteads
And aging mills
And monuments in greening hills.

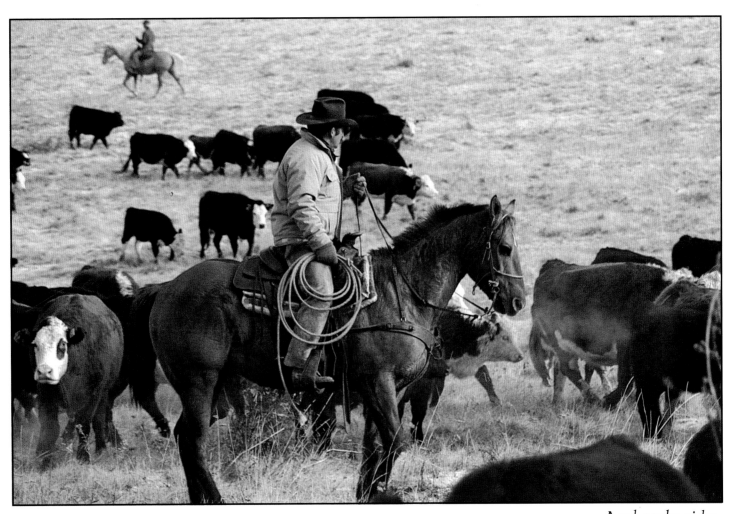

And early rides

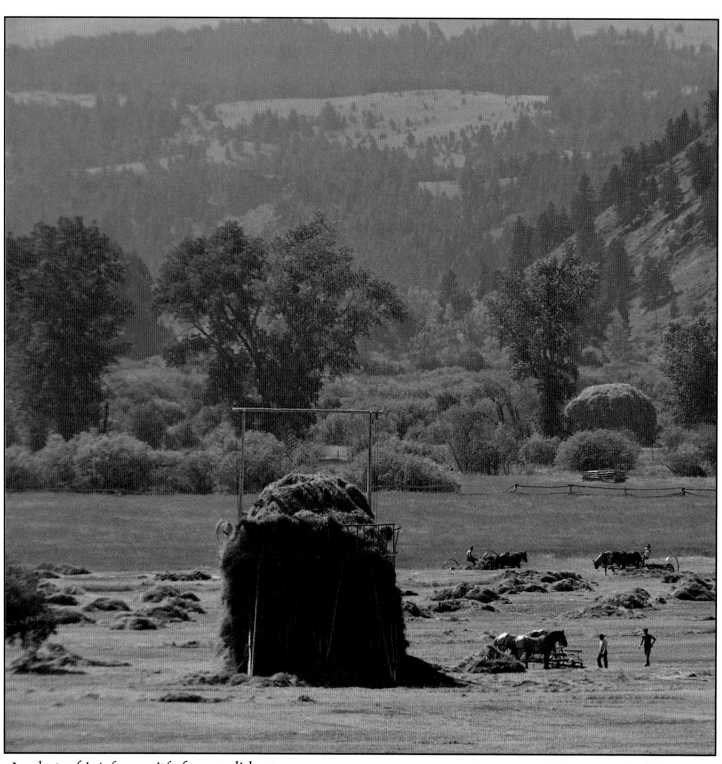

And stackin' hay with beaverslides.

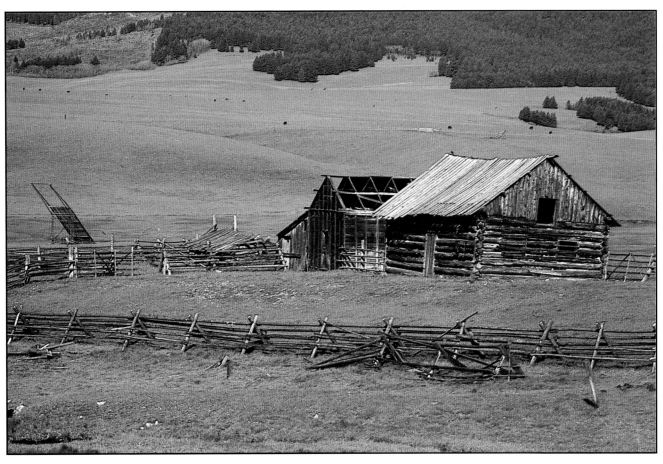

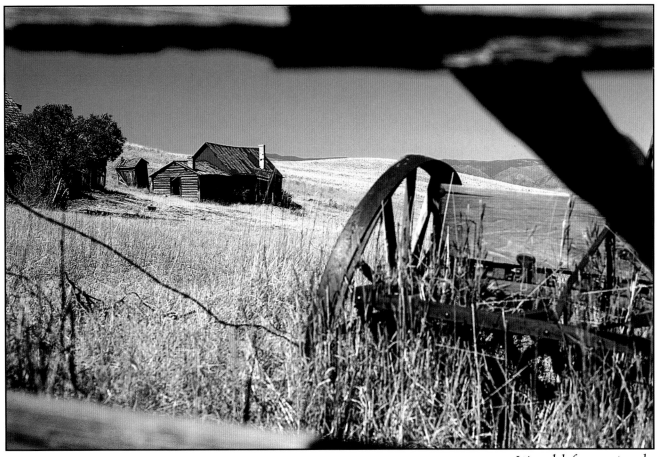

It's old homesteads

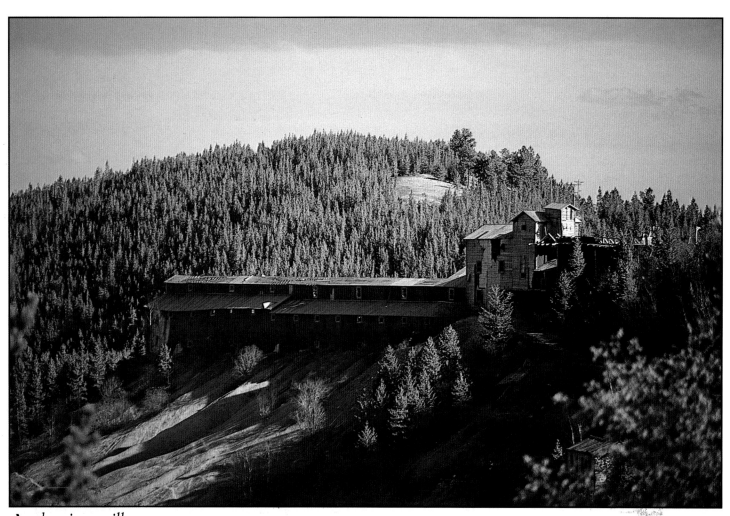

And aging mills

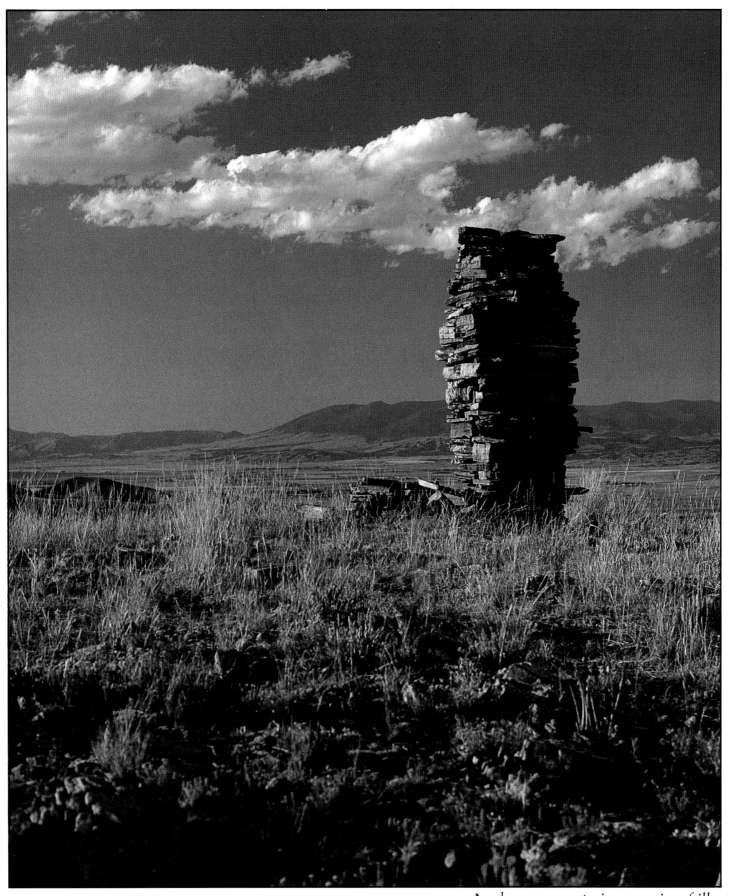

And monuments in greening hills.

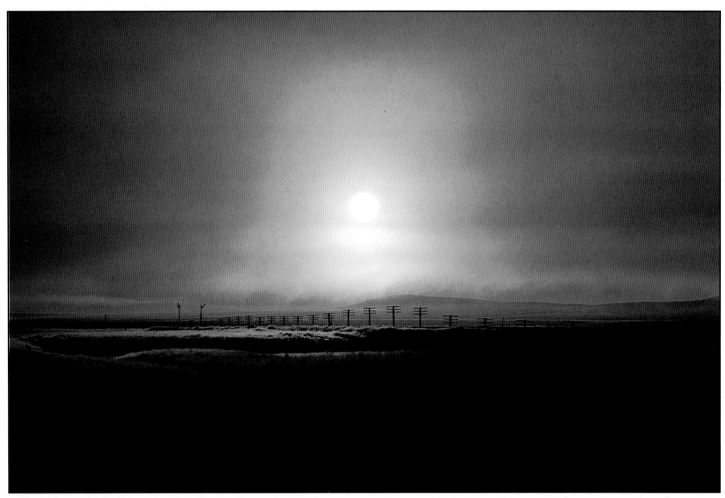

Montana Is ...

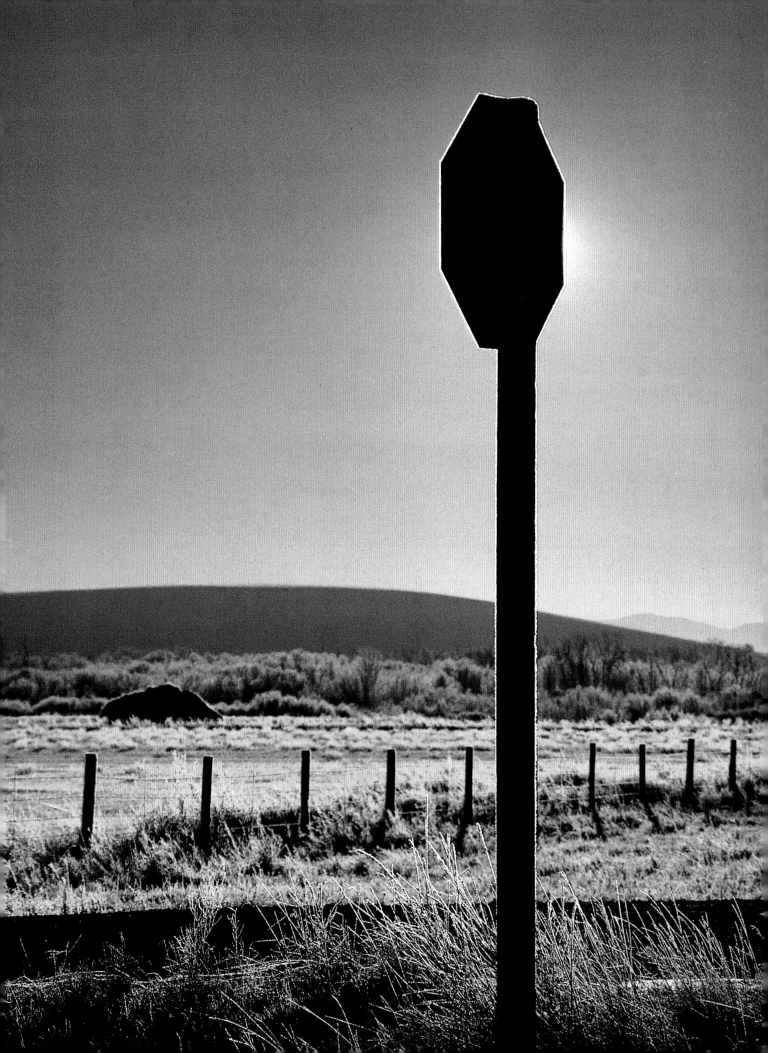

Mike Logan. Sean Logan photo

Yellowstone Is . . .
Yellowstone Park in exuberant verse and full-color photography. Thermal features, wildlife, and more!

96 pp., 8½″ x 11″, 140 color photos, $11.95 softcover

Bronc to Breakfast & Other Poems
This poignant and powerful collection of cowboy poetry captures the essence of ranch life.

80 pp., 5½″ x 8½″, illus., $7.95 softcover
leather-bound edition, signed and numbered (not pictured), $50.00

Bronc to Breakfast Audio Tape
(not pictured), $9.95

Laugh Kills Lonesome & Other Poems
More cowboy poetry from the master storyteller.

80 pp., 5½″ x 8½″, illus., $7.95 softcover

Laugh Kills Lonesome Audio Tape
(not pictured), $9.95

Men of the Open Range & Other Poems (not pictured)
Mike's third collection of spirited Western verse.

80 pp., 5½″ x 8½″, illus., $7.95 softcover

Little Friends (not pictured)
In down-to-earth verse and crisp photography, *Little Friends* celebrates the small, furry mammals of the American West—from the tiny pika to the curious ermine. Certain to delight and educate any young reader.

32 pp., 9¼″ x 8¼″, 40 color photos, $7.95 softcover

About the Author
Veteran photographer Mike Logan's lifelong interest in ranch life has spurred him to capture his observations on film and in verse. Mike's keen insight and expansive western spirit have won him national acclaim, both as a featured poet and emcee at The National Cowboy Poetry Gathering in Elko, Nevada, and as a guest on John Denver's 1991 "Montana Christmas Skies" television special. His words and photographs have also been published in numerous books, magazines, and calendars.

After more than twenty years in the Treasure State, the southeast Kansas native still tells his two sons, Mark and Sean, that he envies them the privilege of growing up in Montana. In *Montana Is . . .* Mike attempts to share, through words and photographs, the way he sees the state—with all the love, admiration, and wonder of an adopted son.

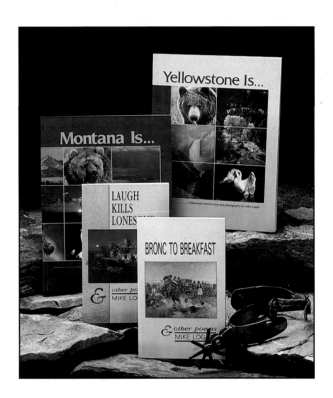

Send orders for *Montana Is . . .* and Mike Logan's other books and tapes to:

Buglin' Bull Press
32 S. Howie
Helena, MT 59601

Add $1.50 per book for postage and handling.